THE GREAT WESTERN R

—— VOLUME SIX ——

SOUTH WALES
MAIN LINE

Stanley C. Jenkins & Martin Loader

AMBERLEY

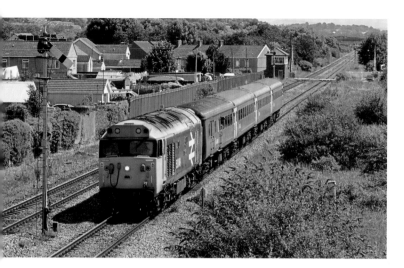

Closure Dates

British Railways closure announcements referred to the first day upon which services would no longer run, which would normally have been a Monday. However, the final day of operation would usually have been the preceding Sunday (or, if there was no Sunday service, the preceding Saturday). In other words, closure would occur on a Saturday or Sunday, whereas the 'official' closure would take place with effect from the following Monday.

Class 50 locomotive No. 50049 *Defiance* approaches Pembrey & Burry Port while working the 10.55 a.m. Cardiff Central to Fishguard Harbour service on 15 July 2006.

First published 2016

Amberley Publishing
The Hill, Stroud, Gloucestershire, GL5 4EP
www.amberley-books.com

Copyright © Stanley C. Jenkins & Martin Loader, 2016

The right of Stanley C. Jenkins & Martin Loader to be identified as the Authors of this work has been asserted in accordance with the Copyrights, Designs and Patents Act 1988.

ISBN 978 1 4456 4126 3 (print)
ISBN 978 1 4456 4138 6 (ebook)

British Library Cataloguing in Publication Data.
A catalogue record for this book is available from the British Library.

Typesetting by Amberley Publishing.
Printed in Great Britain.

HISTORICAL INTRODUCTION

The Great Western Railway was incorporated by Act of Parliament on 31 August 1835, with powers for the construction of a railway between Bristol, Bath, Reading and London. The GWR route, which was engineered by Isambard Kingdom Brunel (1805–59) and built to a broad gauge of 7 feet 0¼ inches, was completed throughout its 118-mile length from London to Bristol Temple Meads on 30 June 1841.

Meanwhile, various branch lines and extensions were being projected, one of these being the Cheltenham & Great Western Union Railway, which was incorporated by Act of Parliament on 21 June 1836 with powers for the construction of railways from Cheltenham to 'the east side of the new cattle market' at Gloucester, and from Gloucester to a junction with the GWR near Swindon. As the proposed line between Cheltenham and Gloucester would otherwise have been parallel to the Birmingham & Gloucester Railway, Parliament decided that this part of the line would be shared between the two companies.

The Cheltenham & Great Western Union Railway was opened between Swindon and Kemble on 31 May 1841, while the northernmost section between Standish Junction and Gloucester was brought into use on 8 July 1844 (in connection with the Bristol & Gloucester line). The Cheltenham & Great Western Union route was completed throughout from Kemble to Standish Junction on Whit Monday, 12 May 1845 – by which time the Cheltenham & Great Western Union Railway had been absorbed by the GWR. At Gloucester, trains terminated in a temporary station that had been opened in conjunction with the Bristol and Gloucester line, but a separate Great Western station was opened in 1851.

THE SOUTH WALES RAILWAY

The Cheltenham & Great Western Union Railway formed an obvious starting point for an undertaking known as 'The South Wales Railway', which had been formed during the 'Railway Mania' with the aim of completing a rail link between Gloucester and Fishguard, on the north Pembrokeshire coast. Branch lines would serve Pembroke Dock and other destinations, the length of the proposed scheme being around 210 miles. The SWR was, from its inception, intimately connected with the Great Western Railway, and with I. K. Brunel as its engineer, it was intended that the line would be a 7-feet broad-gauge route.

The South Wales Railway was, by any definition, a major project, which was designed from its inception as an important main line between England, Wales and Ireland. As such, the proposed railway would form a vital link between three distinct parts of the United Kingdom, with many perceived benefits in terms of mutual trading opportunities and (hopefully) greater political integration. The South Wales Railway was thus seen as 'a great national undertaking to connect the South of Ireland as well as South Wales and the Metropolis'. Its authorised capital was no less than £2,800,000 – an enormous sum by early Victorian standards.

As originally planned, the South Wales line would have avoided Gloucester and crossed the River Severn by means of a bridge between Fretherne and Awre. The SWR scheme was, in consequence, opposed by the traders and residents of the Gloucester area, and there was further opposition from the Admiralty on the grounds that the proposed Severn Bridge would be an impediment to navigation. For these reasons, Parliament refused to sanction the

eastern end of the SWR route and, as authorised on 4 August 1845, the proposed railway would have commenced near Chepstow by a junction with a local undertaking known as The Gloucester & Dean Forest Railway.

To facilitate this change of plan, the promoters of the Dean Forest line had been persuaded to extend their proposed route to Hagloe Farm, near Awre, where connection would be made with the South Wales Railway, but it was later agreed that the Dean Forest line would be cut down to just 7 miles 36 chains of line between Gloucester and Grange Court, near Westbury-on-Severn – the intervening section between Grange Court and Chepstow being built by the South Wales company, while both the South Wales and Dean Forest lines would be leased and worked by the Great Western Railway as part of the GWR broad-gauge system.

Work was soon underway on all of these new lines, but, unfortunately, the railway construction boom was brought to an abrupt halt by a series of failed harvests during the later 1840s. At a time when most of the nation's surplus capital was tied up with new railway schemes, the Victorian stock market collapsed and, in these circumstances, many of the grandiose projects promoted during the Railway Mania were severely retarded, while others were abandoned in their entirety.

Despite these problems, the first section of the South Wales Railway was ceremonially opened between Chepstow and Swansea, a distance of 75 miles, on Tuesday 18 June 1850. The great day was marked in appropriate fashion by the running of a special train conveying the SWR and GWR directors and their invited guests. The proceedings commenced at Chepstow station, where 'a vast concourse of people' had assembled to witness the departure of the official 'First Train', which left at 9.00 a.m. and was greeted by 'the ringing of bells and firing of cannon' as it proceeded in triumphal fashion along the new line to Newport, Cardiff and Swansea. Regular public services commenced on Wednesday 19 June – although some of the intermediate stations were not brought into use until slightly later.

The Dean Forest line from Gloucester to Grange Court was opened on 19 September 1851, together with the intervening portion of the South Wales Railway between Grange Court and Chepstow East. The eastern portion of the SWR main line was finally opened throughout to Gloucester on 19 July 1852, following the completion of the Wye Bridge at Chepstow. At its western end, the SWR line was extended to a temporary terminus at Carmarthen on 11 October 1852, but further progress was impeded by the underlying economic crisis, and by the catastrophic effects of the Irish Famine – which made Fishguard a less attractive destination for this important main-line scheme. On 2 January 1854, however, the South Wales line was extended to Haverfordwest and finally, on 15 April 1856, the route was completed throughout to Milford Haven (Neyland) – some 172 miles from Gloucester and 285¼ miles from Paddington.

The completed railway was double track between Grange Court and Carmarthen, and single track between Carmarthen and Neyland, though a second line was added in 1857. The line was laid partly with bridge rails bolted to longitudinal timbers and partly with Barlow rails – which were laid directly onto the ballast without the need for sleepers. The principal engineering works included tunnels at Newport (742 yards) and Cocket (789 yards), and bridges or viaducts at Chepstow, Landore, Newport, Loughor, Kidwelly and Carmarthen. The South Wales Railway was worked by the Great Western under leasing arrangements until August 1863, when it was amalgamated with the parent company under the provisions of an Act of Parliament that had been obtained on

21 July. The line remained a broad gauge route until 1872, when it was converted to the standard gauge of 4 feet 8½ inches.

Until 1886, South Wales main line services had followed a circuitous route via Swindon, Gloucester and Chepstow, but in 1872 the GWR obtained Parliamentary consent for a tunnel beneath the Severn Estuary. Work began in 1874, and the 4½ mile tunnel was completed in 1886. The best trains between Paddington and South Wales were then diverted onto the new route, which converged with the original SWR main line at a point known as Severn Tunnel Junction. Further changes ensued as a result of the grouping of railways in 1921–23, which brought a variety of hitherto independent Welsh lines into an enlarged Great Western Railway, resulting in a number of changes at Cardiff and other places on the South Wales main line, where steps were taken to fully integrate the absorbed lines with the main line system.

THE FISHGUARD & ROSSLARE RAILWAYS & HARBOURS COMPANY

Although the Irish Famine had dealt a severe blow to the original Fishguard scheme, it was decided that an alternative cross-channel steamer service would be arranged between New Milford (Neyland) and Waterford. Accordingly, in 1856 the GWR commenced its long hoped-for steamer service to Ireland in conjunction with Messrs Ford & Jackson, who arranged a thrice-weekly service using the screw steamer *City of Paris*. The SS *City of Paris* was soon joined by the iron-paddle steamer *Malakhoff*, and a much larger paddle vessel known as the *Pacific*, which was put into service between New Milford and Cork in 1857.

In 1871 the Great Western signed a working agreement with the Waterford & Limerick Railway involving through rates and fares, connecting services and guaranteed dividends for W&LR shareholders. The agreement came into force on 21 July and in view of its close associations with the Waterford & LimerickcCompany, the Great Western Railway assumed full control of Messrs Ford & Jackson's steamer operations on 1 February 1872, paying £45,000 for the paddle steamers *Malakhoff*, *Vulture*, *South of Ireland* and *Great Western*. Additionally, the company placed orders for four new 960-ton paddle vessels, which would be built at a cost of £100,000. The first two, *Limerick* and *Milford*, appeared in 1873, but the *Limerick* was unfortunately wrecked around 1874, and the third vessel then took her name.

The Waterford & Limerick Railway gave the GWR access to Tipperary, Limerick, Ennis and other small towns in the south of Ireland, but the cross-channel steamer route from New Milford to Waterford was long and time consuming, and when the Dublin & Wicklow line finally reached Wexford, on 17 August 1872, plans for a short sea crossing between Fishguard and Rosslare were revived. In the event, it would be several years before the Fishguard to Rosslare route was in operation and when, in the 1890s, construction finally began, the whole complexion of railway politics had changed.

The long standing alliance between the Great Western and Waterford & Limerick companies had come to an end in January 1901, when the latter railway was absorbed by the Great Southern & Western Railway. Perhaps more significantly, the GS&WR now moved into much closer association with the GWR. Meanwhile, the Fishguard Bay Railway & Pier Company, which had obtained powers to build a new railway and harbour at Fishguard, obtained further powers to take-over Rosslare Harbour and the Waterford & Wexford Railway, while in 1895 the company was empowered to operate steamers between Fishguard and Rosslare. The undertaking had, by that time, changed its name to the Fishguard & Rosslare Railways & Harbours Company.

Alarmed at this threat of competition, the GWR and the GS&WR decided jointly to takeover the Fishguard company and, in 1898, the allies obtained powers to do this and to construct 52 miles of new railways in Ireland. A further Act of Parliament, obtained in the following year, authorised the GWR to extend and improve the port facilities at Fishguard.

Massive engineering works were necessary at Rosslare and at Fishguard, where solid cliffs rising to a height of 200 feet had to be blasted away for a distance of about half a mile in order to create space for a new station. In connection with this scheme, it was decided that the GWR would takeover a local concern known as the North Pembrokeshire & Fishguard Railway, which was attempting to revive a moribund line that ran from Clynderwen to the slate quarries at Rosebush, about 10 miles to the south-east of Fishguard. The Rosebush route was reopened in 1895, and in 1899 it was completed throughout to Fishguard, via Puncheston and Letterston. In practice, this severely-graded branch was unsuitable for main line traffic, and in consequence it was agreed that an entirely new 'cut-off' line would be constructed between Clarbeston Road and Letterston, using part of the route that had been abandoned by the SWR as far back as the 1840s. Having obtained Parliamentary consent for the 'Clarbeston Road & Letterston Railway', the GWR commenced work in 1904, and the Fishguard to Rosslare service was inaugurated on Thursday 30 August 1906.

The new line from Clarbeston Road was initially single track throughout, although double track was installed between Clarbeston Road and Letterston Junction in May 1907. There was, at first, just one intermediate station at Fishguard & Goodwick, in addition to the new terminus at Fishguard Harbour. The lavish scale of the infrastructure at Fishguard proclaimed that an extensive traffic was planned, both in passengers and in agricultural products. The new passenger station had two 800 feet island platforms, together with extra covered accommodation for the transfer of goods traffic between railway and steamer. Considerable thought had been given to cattle traffic, no less than sixty-five large pens having been constructed. Other facilities at Fishguard included staff housing, a power station, a slaughterhouse, half-a-mile of quays, and a sheltered anchorage enclosed by a breakwater some 2,500 feet in length.

Three new turbine steamers were delivered in time for the opening of the service in 1906. They were named *St Patrick*, *St David* and *St George*, while a fourth vessel, the *St Andrew*, appeared in 1908. These four vessels were some 350 feet long, with a gross tonnage of around 2,500 tons and a maximum speed of around 23 knots, though such speeds were never attained in regular service. The new steamers were, in effect, miniature ocean liners, the cabins and other accommodation for first-class travellers being regarded as particularly luxurious. The public rooms included a large reading room, a smoking room and a dining room with seating for ninety passengers, while the private cabins provided sleeping accommodation for 178. The public areas sported parquet floors and were lined with wood panelling.

There can be no doubt that the Great Western was proud of its innovative turbine steamers and the new cross-channel service, and it was expected that travellers would soon be flooding into Southern Ireland in considerable numbers. A massive publicity campaign was mounted and, to help prepare the ground, a special handbook entitled *Instructions Relating to Irish Traffic* was sent out to all stations for the enlightenment of the company's servants. The GWR also maintained its own staff in Ireland under the control of Mr E. J. O'Brian Croker, the Dublin traffic manager. Other officials included Inspector M. Costello at Rosslare, Inspector R. O'Toole at Wexford and agents in Belfast, Kilkenny, Waterford and Limerick.

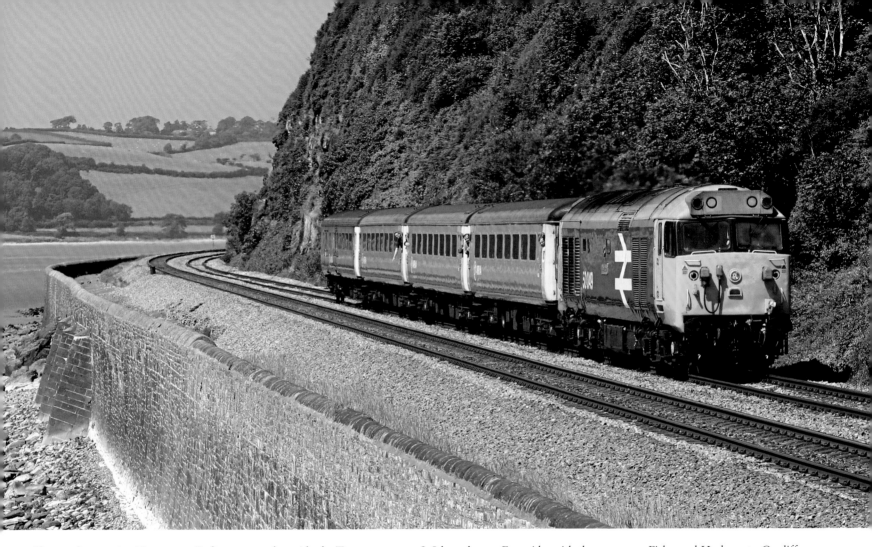

Class 50 locomotive No. 50049 *Defiance* runs alongside the Towy estuary at St Ishmael, near Ferryside, with the 1.35 p.m. Fishguard Harbour to Cardiff Central service on 15 July 2006.

These gentlemen controlled various GWR facilities in Ireland, including wharfage, cattle pens and warehouses at Rosslare and Waterford. In addition, the Great Western operated its own road vehicles in Dublin, providing 'cartage in that City within the usual limits'.

It is clear that the Great Western's Irish operation was ambitious and highly sophisticated. It was also a matter of some pride, for here was a great railway company, which already had special affinities with Cornwall and Wales, about to extend its operations into Ireland – the final Celtic stronghold. With faster steamers, and new 'cut-offs' on the South Wales line, it was envisaged that Southern Ireland would become another Cornwall, within easy reach of London and other centres of population. Engines were renamed to underline the 'Irish connection', and the appreciative traveller, standing on the departure platform at Paddington, would have noted *Killarney*, *Waterford* and *County Cork* amid the more familiar (and equally melodious) Cornish locomotive names.

Sadly, this dream was shattered by the Easter Rising of 1916, the 'Black & Tan' campaign and the vicious civil war which followed. By 1921, twenty-six mainly Roman Catholic Southern Irish counties had seceded from the United Kingdom to form the Irish Free State (now the Irish Republic), leaving just six predominantly Protestant counties within the Union. Initially, the results were disastrous for the Great Western's cross-channel tourist traffic. Moreover, the severing of most links between London and Dublin effectively ended the once prestigious governmental traffic that had hitherto passed between these two cities. A further blow came with the imposition of customs duties between the newly-created Irish Free State and the United Kingdom.

By the 1930s there had been a modest revival, and with new ships on the Fishguard to Rosslare route, and a renewed publicity campaign, there seemed no reason why the lost Irish traffic should not revive and prosper. There was nevertheless something missing, and one feels that the Great Western had lost much of its former interest. The cross-channel service was conducted efficiently, and the company retained its share in the Fishguard & Rosslare Railways & Harbours Company, but there were no longer any particular attempts to identify the GWR with Southern Ireland.

The GWR, its directors and indeed many of its shareholders, made no secret of their strongly unionist stance, and one is led to the inevitable conclusion that politics and personalities must have played a part in this change of attitude towards Ireland. Sir James Inglis (1851–1911), the Great Western Railway's chief engineer from 1892 until 1904 and the General Manager thereafter, had been particularly enthusiastic about the Fishguard scheme. He had himself designed the new harbour works, and was probably the driving force behind the celebrated Killarney excursions, which began in 1907. Sadly, Sir James died in December 1911, and internal politics within the GWR made it unlikely that his expansionist plans would be continued.

THE DEVELOPMENT OF TRAIN & FERRY SERVICES

The South Wales main line is somewhat peculiar, in that it has no obvious western terminus. The pattern of operation on the South Wales route has, for many years, involved the provision of fast and frequent train services between Paddington, Newport, Cardiff and Swansea. The latter station was the terminus for many services although, in steam days, around half a dozen main line workings continued westwards to Fishguard, Milford Haven, Pembroke Dock or Neyland. Until 1926, the best trains had called at Carmarthen Junction but, following the closure of that station, most trains ran into and out of Carmarthen town, despite the need for an

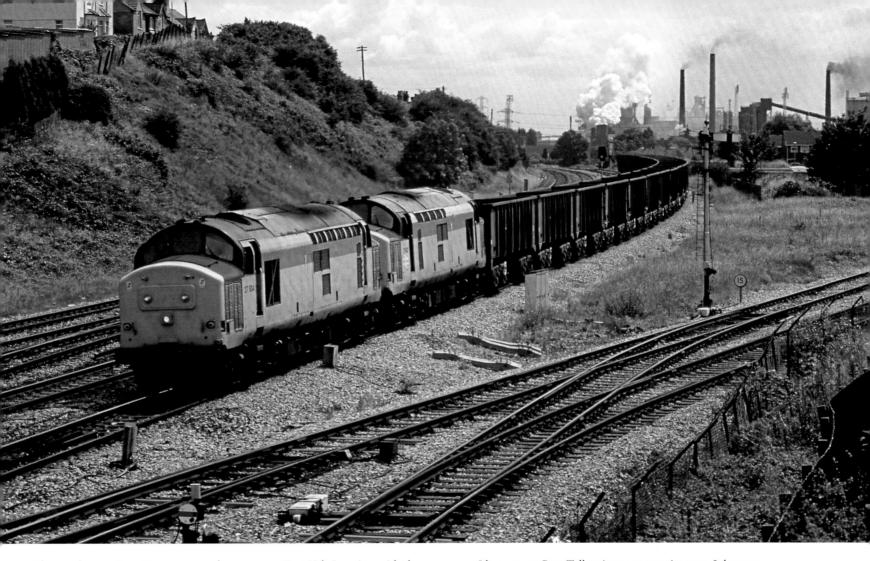

Class 37 locomotives Nos 37904 and 37902 pass East Usk Junction with the 11.50 a.m. Llanwern to Port Talbot iron ore empties on 2 July 1990.

intermediate reversal. Similarly, in earlier years, through services to and from West Wales had avoided Swansea, but after 1926 most trains called at Swansea, necessitating another reversal.

In the 1890s, there were four trains each way between Paddington and New Milford, together with the Cork Express, which ran on Tuesdays, Thursdays and Saturdays only. In a letter to the November 1956 issue of *The Railway Magazine*, H. Fayle recalled that, when he first used the route in 1898, the evening train that was scheduled to leave Paddington at 6.05 p.m. ran non-stop to Swindon, but it then became 'annoyingly slow, and followed the longer route via Gloucester'. New Milford was eventually reached at 1.15 a.m. on the following morning, 'nearly twenty stops having been made after Swindon'. He added that there were no refreshment facilities whatsoever; though from 1900 onwards they were available on the Cork Express. With luck, the steamer would reach Waterford (Adelphi Wharf) 'at about 9.30 a.m., in time to connect with a train that was leaving the North station at 10.20 a.m. for Limerick'.

In 1906, the boat trains were transferred to the Fishguard line, but some main line trains continued to run to and from the station formerly known as New Milford, which was renamed Neyland in that same year. In the early 1920s, the Fishguard route was normally served by three main line services, whereas Neyland remained the final destination for two of the Paddington express services.

The original Fishguard to Rosslare steamer service provided both day and night sailings, with connecting rail services on both sides of the Irish Sea. In 1906, the westbound services departed from Paddington at 8.45 a.m. and 8.45 p.m., the scheduled arrival times at Killarney being 10.10 p.m. and 10.35 a.m. respectively. In the opposite direction, the corresponding eastbound workings left Killarney at 7.33 a.m. and 7.00 p.m., while the connecting services from Fishguard reached Paddington at 10.10 p.m. and 10.35 a.m.

respectively. The service was increased to three sailings each way, with connecting rail services, when the Waterford steamers were transferred to Fishguard and, shortly afterwards, the City of Cork Steam Packet Company introduced a thrice-weekly service between Fishguard and Cork. A similar pattern of operation persisted for many years with the one significant development being the ending of regular daytime sailings during the First World War.

In July 1947, at the very end of the Great Western era, the principal down services left Paddington at 8.55 a.m., 11.55 a.m., 1.55 p.m., 3.55 p.m. and 9.25 p.m. and reached Carmarthen at 2.23 p.m., 5.55 p.m., 2.05 p.m., 11.55 p.m. and 5.12 p.m. respectively. An additional working left London at 3.55 p.m. on Mondays, Wednesdays and Fridays, reaching Carmarthen at 9.17 p.m. In 1947, the 5.55 p.m. from Paddington terminated at Carmarthen, but the other services were through workings to or from Fishguard or other Pembrokeshire destinations. In the opposite direction, the balancing up services departed from Carmarthen at 7.30 a.m., 9.49 a.m., 12.20 p.m., 1.39 p.m. and 8.32 p.m., and reached Paddington at 1.30 p.m., 3.40 p.m., 6.15 p.m., 8.00 p.m. and 1.20 a.m. respectively.

The 1947 timetable was not quite as good as the one that had pertained before the Second World War, the main difference being that, in 1939, the 3.55 p.m. from Paddington had been a daily working, and there had been an extra service at 7.55 p.m. Otherwise, travellers between London and Carmarthen had enjoyed a very similar service since 1924, when the GWR had adopted a 'clock-face' departure system for daytime services on the South Wales main line.

On 5 June 1950, British Railways introduced 'The Red Dragon' as a prestigious named service between Paddington, Newport, Cardiff, Swansea and Carmarthen, while on 8 June 1953 'The Pembroke

Coast Express' was introduced as a fast service between Paddington, Tenby and Pembroke Dock. A further named train, 'The Capitals United Express', originally ran between Paddington and Cardiff, but it later worked through to Pembroke Dock and Neyland.

In 1957, the Pembroke Coast Express was the fastest service between London and South Wales. Leaving Paddington at 10.55 a.m. it covered the 133½ miles between London and Newport in 131 minutes, and then made a fast run to Swansea; here, the restaurant car portion was detached, while the main portion continued to Carmarthen, Whitland and Tenby, arriving at Pembroke Dock at 5.26 p.m. The return working left Pembroke Dock at 1.05 p.m., and having been re-united with the restaurant car portion at Swansea, the up service was due in Paddington at 7.45 p.m. The usual motive power between Swansea and Paddington was a 'Castle' Class 4-6-0, and the train was smartly turned-out in chocolate and cream livery.

Sleeping cars were a feature of operations on the South Wales main line during the GWR period. In 1947, for example, first- and third-class sleeping accommodation was available on the 1.00 p.m. down service to Swansea, from where the sleeping cars were worked forward to Carmarthen at 9.08 a.m. In the up direction, the vehicles were attached to the 8.32 p.m. to Paddington. These arrangements were amended in 1962, when BR introduced a new 12.45 a.m. sleeper car train from Paddington, which reached Carmarthen at 7.00 a.m. and Milford Haven at 9.13 a.m.

This new service did not run throughout to Milford Haven in the down direction, the sleeping cars being attached to the 7.55 a.m. stopping train from Carmarthen to Milford Haven. However, in the up direction, the return working ran through from Milford Haven at 10.00 a.m., leaving Carmarthen at 11.35 a.m. and reaching Paddington at 5.30 p.m. – an acceleration of 2 hours 40 minutes from Milford Haven and 2 hours 14 minutes from Carmarthen.

In the summer of 1965, there were ferry sailings from Fishguard to Rosslare at 2.15 a.m., 7.00 a.m., 2.30 p.m. and 5.00 p.m., together with a night sailing to Cork at 11.45 p.m. on Mondays, Wednesdays and Fridays only. The Rosslare services were provided by BR vessels, then sailing under the 'Sealink' banner, while the Cork services were handled by the City of Cork Steam Packet Company. In the eastbound direction, the balancing services left Rosslare at 4.00 a.m., 12.00 noon, 10.45 p.m. and 11.25 p.m., with a thrice-weekly service from Cork Penrose Quay at 6.00 p.m. All of these sailings were rail-connected, the Fishguard to Rosslare route being run as an adjunct to the trains, with through tickets to a range of destinations in Britain and Ireland.

Unfortunately, the Fishguard to Rosslare route was dealt a major blow in July 1984 when Sealink's thirty-seven ships, twenty-four cross-channel routes and ten harbours were sold to an American company known as 'Sea Containers'. The historic link between railways and cross-channel ferry services was thereby severed and, for a time, the very future of the Fishguard route seemed to be in doubt. In the event, the Fishguard route managed to survive with a residual service which, by 1993, had been reduced to just two up and three down services per day.

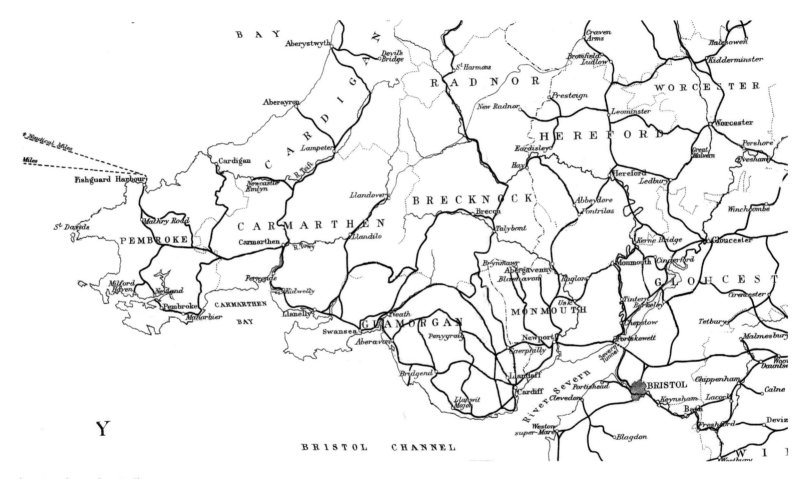

The South Wales Railway

A map of the Great Western system in south and west Wales. The original South Wales Railway main line commences at Gloucester and follows the Severn Estuary towards Chepstow before turning westwards via Newport, Neath and Swansea. The route splits into three main arms beyond Carmarthen, with the main route continuing north-westwards to Fishguard Harbour. The Severn Tunnel 'cut-off' route can be seen running from east-to-west, immediately to the north of Bristol.

Gloucester Central

The Birmingham & Gloucester Railway, which subsequently became part of the Midland Railway system, reached Gloucester on 12 June 1840, while the Great Western did not arrive until 12 May 1845, when the Cheltenham & Great Western Union line was completed throughout from Kemble. The original GWR station was a terminus, but it became a through station on 19 September 1851, when the Gloucester & Dean Forest line was opened between Gloucester and Grange Court. This first GWR station occupied a restricted site, on a narrow strip of land between Gloucester Workhouse and the Birmingham & Gloucester station. There were two very short platforms and an over-all roof, together with a Brunel-style goods shed – the latter structure being sited to the north of the passenger station and served by a siding that ran behind the down platform and divided into two dead-end spurs before entering the shed itself.

A much improved station was brought into use shortly after the opening of the Dean Forest line, and this new station formed the nucleus of all later extensions and developments. This first permanent station was one of the Great Western's curious 'single-sided' stations, with just one long platform for up and down traffic. A second platform for up traffic was added in 1889, and the original platform on the south side was then used for down traffic. In its fully-developed form, Gloucester GWR station consisted on two very long platforms on either side of a quadruple track layout – the innermost lines being for through traffic. Intermediate crossovers linked the up and down platforms to the through lines, and by this means two trains could be accommodated on each platform. The upper picture provides a glimpse of Gloucester GWR station during the 1850s, while the lower photograph was taken from a similar vantage point over a century later.

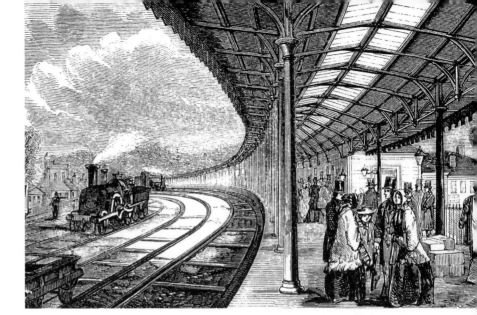

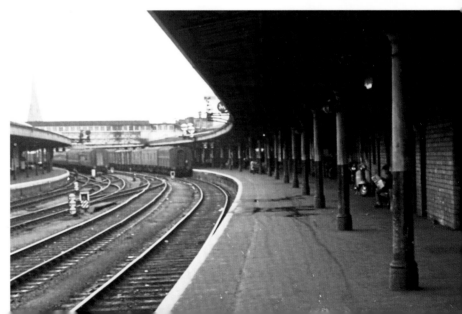

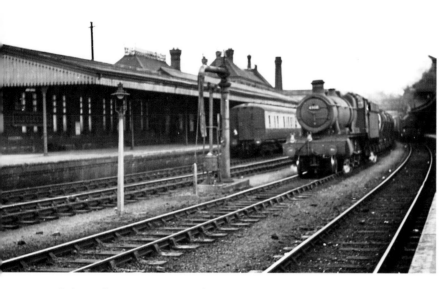

Right: Gloucester Central

Gloucester Central was an archetypal GWR station, its passenger facilities having been extensively rebuilt during the later years of the nineteenth century, when the Great Western erected one of its standard hip-roofed brick buildings, with tall chimney stacks and distinctive 'French chateau' style turrets. The chimneys featured 'over-sailing' upper courses, while the doorways and window apertures were arranged in pairs, many of which were grouped beneath common lintels. The main station building, on the down side, boasted a range of accommodation including a booking office, waiting rooms, refreshment room, parcels office, station master's office, telegraph office, mess rooms, toilets and a bookstall. Facilities on the up platform included further waiting rooms and staff accommodation. In earlier years, there had also been a separate up-side booking office, but in November 1932 *The Great Western Railway Magazine* reported that 'the arrangements for booking passengers, collecting tickets and dealing with parcels, etc., at Gloucester' were 'to be re-organised by concentrating the work on the down side'.

Left: Gloucester Central – The Rebuilt Station

Gloucester GWR station consisted of two very long platforms on either side of a quadruple track layout – the innermost lines being intended for through traffic, while intermediate crossovers linked the up and down platforms to the through lines and, by this means, two passenger trains could be accommodated in each platform. Terminal bays were provided at the departure end of each platform, that at the western end of the down platform being known as 'The Hereford Bay', while its counterpart at the eastern end of the main up platform was referred-to 'The Chalford Bay'. An additional bay platform, which was sited alongside the Hereford Bay, was used for parcels, horse boxes and miscellaneous traffic. The up and down sides of the station were linked by a fully-enclosed footbridge and, in addition, an underline subway provided a pedestrian link between Station Road, on the down side of the line, and Great Western Road on the other side of the station.

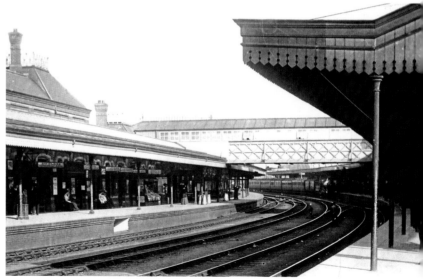

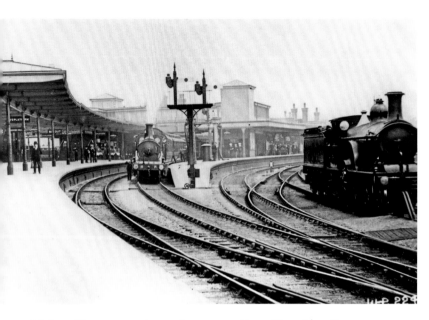

Left: Gloucester Eastgate – The Midland Station

An immensely-long footbridge at the eastern end of Gloucester Central station enabled travellers to cross an array of intervening sidings in order to reach the neighbouring Midland Railway station, which was renamed 'Gloucester Eastgate' in 1951. The station, which was situated on a curve, had four platforms – Platforms 2 and 3 being the main platforms for up and down traffic respectively. Platform 1, on the north side of the main up platform, was a terminal bay, whereas Platform 4 was the outer face of an island used by down trains heading towards Bristol. Eastgate station was surrounded by an array of goods lines and sidings, including a group of carriage sidings on the north side that occupied the site of the original Birmingham & Gloucester terminus. Further sidings were available on the south side of the station, and a connecting line between the GWR and Midland stations served as an exchange siding. The two stations were formally combined in June 1968, but Gloucester Eastgate was closed in December 1975.

Right: Gloucester Central – Some Signalling Details

The area around the passenger station was, for many years, signalled from three signal cabins, which were known as 'Gloucester West', 'Gloucester Middle' and 'Gloucester East' boxes. Gloucester West Box, which was sited to the west of the platforms on the up side, was a typical late-Victorian brick-and-timber design, with a gable roof and small-paned windows; internally, in contained a 33-lever frame. Gloucester Middle box, in contrast, was an unusual elevated structure that towered high above the up platform. It was of timber construction with small-paned windows, a hipped roof and a 51-lever frame. The Great Western carried implemented a re-signalling scheme during the 1930s and, as a result, Gloucester Middle box and the original Gloucester East box were abolished, their functions being taken over by a new east box that was brought into use in 1938. The photograph shoes the replacement cabin, which was a traditional, hip-roofed design with a hipped roof and a 110-lever frame.

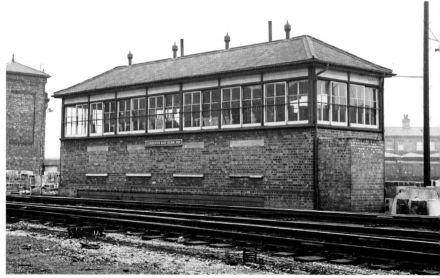

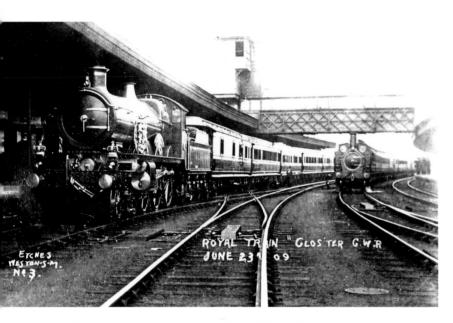

ROYAL TRAIN GLOSTER G.W.R
JUNE 23 09

Left: Gloucester – A Royal Train

This old postcard view shows the royal train at Gloucester on 23 June 1909 on the occasion of King Edward VII's visit to the Royal Agricultural Show. The elevated Gloucester Middle signal cabin can be seen in the background. Great Western traffic statistics suggest that Gloucester was one of the busiest traffic centres of the GWR system. In 1903, for example, the station issued 322,014 tickets, rising to 331,811 in 1913 and 363,828 by 1923. In that same year, there were 1,741 season-ticket holders, while 233 staff were employed in the passenger and goods departments (with many more in the locomotive and engineering departments). By the 1930s, the station was issuing approximately 260,000 ordinary tickets per annum, together with around 1,600 season tickets.

Right: Gloucester Central – The Old Yard

Class 47 No. 47592 waits in the up platform at Gloucester during the mid-1980s. The area immediately to the north of the platform was formerly occupied by a goods yard known as the 'Old Yard'. This spacious yard contained over two dozen sidings, one of which served a huge goods shed. The shed was a standard Great Western design with an internal loading platform and six cart entrances on its north side; its external dimensions were approximately 580 feet by 42 feet at ground level, and it was covered by a gable roof with six large skylights. The various sidings were laid out in distinct groups, some of which functioned as storage or marshalling sidings, while others were used for loading or unloading coal or other forms of goods traffic. There were, for example, eight parallel sidings on the north side of the Chalford Bay, and those nearest the passenger station were normally occupied by coaching stock, whereas the adjacent sidings were general-purpose storage or marshalling roads for goods traffic.

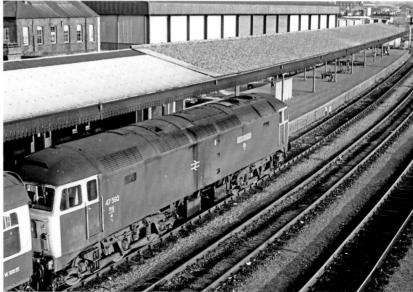

Right: **Gloucester – The New Yard**

Class 47 locomotive No. 47807 passes Gloucester New Yard with the 8.07 a.m. Bristol Temple Meads to Edinburgh service on 5 August 1989. With the Speedlink wagonload freight network still in operation at that time, there were still plenty of varied freight vehicles stabled in the yard. In fact, a couple of years previously, the amount of freight handled here had increased considerably following the closure of Severn Tunnel Junction as a freight handling centre.

Left: **Gloucester Central – The New Yard**

Although Gloucester station is, in effect, situated at the end of a short branch, a direct north-to-south line is available to the east of the station, and this was the site of another large goods yard known as the 'New Yard'. In the pre-Grouping period, the GWR goods yards at Gloucester handled around 270,000 tons of freight per annum, roughly half of this traffic being in the form of general merchandise. There was comparatively little coal traffic, some 27,596 tons being handled in 1913 while, in the 1930s, the Great Western goods yards dealt with about 30,000 tons each year. The picture shows Class 37 locomotive Nos 37375 and 37707 passing a virtually abandoned Gloucester New Yard with the 7.15 a.m. Pathfinder Tours Newport to Doncaster 'Metallic Maiden' railtour on 18 October 2003. With the end of the Speedlink wagonload freight service in 1991, this formerly busy yard ceased to have any practical use.

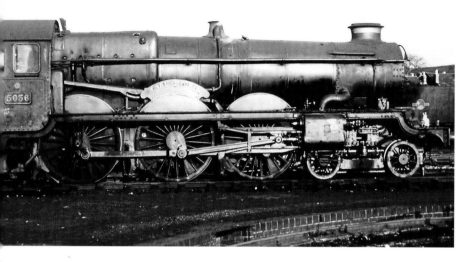

Gloucester – The Engine Shed

Gloucester was a Mecca for locomotive enthusiasts during the days of steam operation – the frequent juxtaposition of GWR and LMS engines being a source of endless fascination. Gloucester GWR engine shed, which was coded '85B' in British Railways days, was situated to the east of the station, and it normally had an allocations of around sixty locomotives. There were in effect two conjoined shed buildings, one of which had a twin-gable roof spanning six tracks, while the other had an unusually high single-gable roof covering four terminal roads. There were thus ten shed roads in all, together with a turntable and the usual facilities for coaling and watering locomotives. In the 1920s, the shed normally housed around forty engines, though by 1948 Gloucester's allocation had risen to sixty-five steam locomotives and one diesel railcar, seventeen of these engines being Castles, Halls or other Great Western 4-6-0 types.

The upper photograph is a broadside view of Castle Class 4-6-0 No. 5056 *Earl of Powis* at Gloucester shed in February 1964. This locomotive, which was originally named *Ogmore Castle*, was built in 1936 and withdrawn from service in November 1964. The lower view shows 45XX Class 2-6-2T No. 4564.

Opposite: Gloucester
A general view of the engine shed.

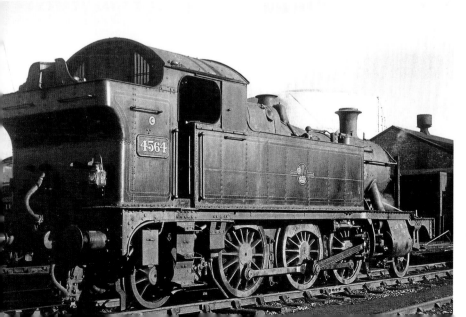

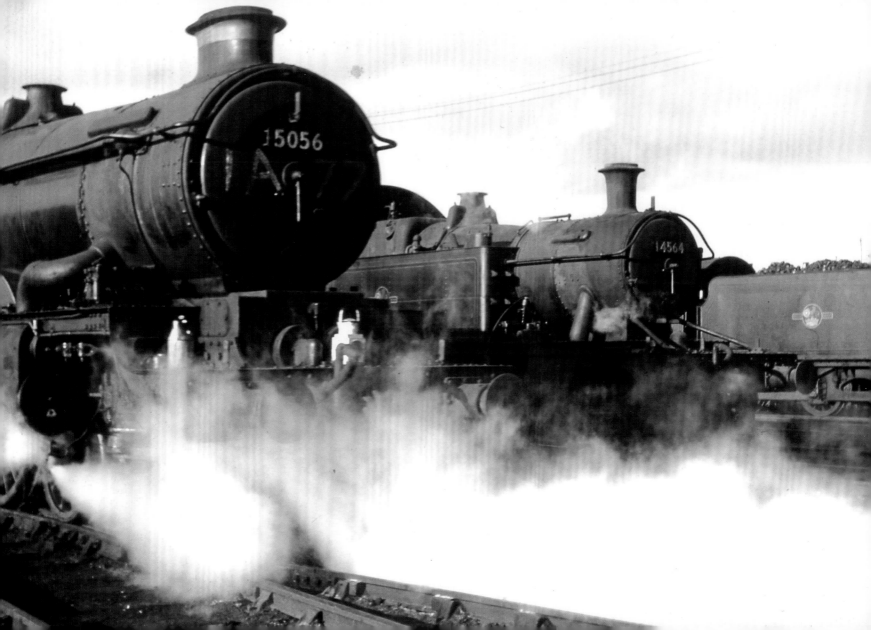

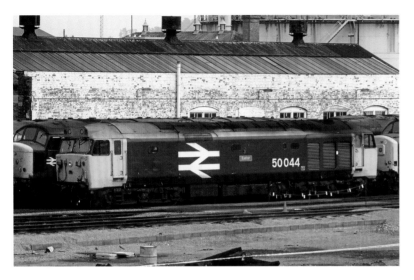

Gloucester

Left: Class 50 locomotive No. 50044 *Exeter* rests between duties at Gloucester Horton Road depot on 26 August 1984. Keeping it company are an unidentified Peak Class locomotive and Class 37 No. 37129.

Below Left: With the unmistakable tower of Gloucester Cathedral in the background, grime-encrusted Class 45 locomotive No. 45058 rests in Horton Road depot in company with a Class 117 multiple unit on 6 July 1985. This engine managed to last almost to the end of Class 45 operations, being withdrawn in September 1987. Like many of its class it ended up dumped at March, before eventually being moved to Scotland, where it was finally cut up by MC Metals of Glasgow in 1994.

Below Right: A numerical coincidence at Gloucester Horton Road depot on 27 January 1990. Nos 37355 and 47355 not only have similar numbers, but at that time they were also wearing identical liveries – the Trainload Freight Distribution colour scheme. No. 37355 reverted to its original TOPS number of 37045 a few months after this picture was taken, while in 1994, 47355 briefly changed its identity to 47391!

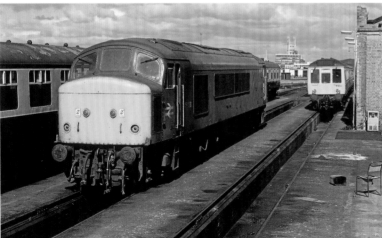

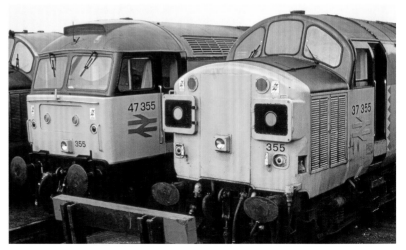

Left: **Gloucester**
The first production HST power car, No. 43002, received the name *Top of the Pops* on 30 August 1984, and the nameplate can clearly be seen in this view as it arrives at Gloucester with the 10.39 a.m. Manchester Piccadilly to Plymouth service on 21 August 1985. The train is just crossing over the Horton Road level crossing, a notorious traffic bottleneck at the east end of the passenger station, which this train will again traverse after reversing at Gloucester station, as all north to south services have to do. It will depart on the lines in the foreground.

Right: **Gloucester**
Class 50 locomotive No. 50006 *Neptune* darkens the sky as it departs from Gloucester with the 7.47 a.m. Cardiff Central to Edinburgh service on 6 July 1985; this locomotive would work the train as far as Birmingham New Street. Sister engine No. 50004 *St Vincent* can be seen on the right waiting to follow it out of the station with the 9.15 a.m. Gloucester to Swindon parcels service. Gloucester cathedral dominates the skyline in the background.

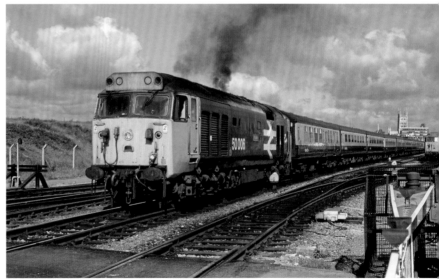

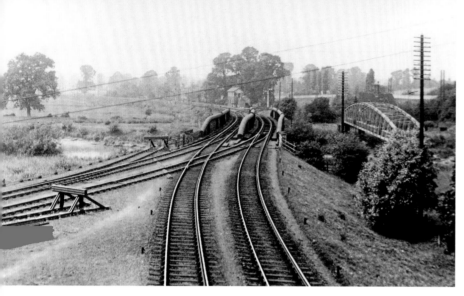

Over Junction and the Gloucester Docks Branch

On leaving Gloucester, trains cross London Road on a girder bridge and proceed north-westwards through an urban landscape. Turning west-north-westwards, the route soon reaches open countryside and, having traversed an expanse of low-lying meadows, the railway is carried across a branch of the River Severn on a girder bridge. Beyond, the route continues westwards for a short distance and, after passing beneath a road overbridge, trains reach the site of Over Junction, where the Ledbury branch diverged north-westwards from the man line. Over Junction also marked the start of the GWR docks branch, which formerly converged from the south-east by means of a double-track junction. The Ledbury route was opened throughout on 27 July 1885, while the docks branch was brought into use on 20 March 1854.

This busy freight-only line ran southwards for 1 mile 16 chains to reach Anthony Quay, on the west side of the docks. The line was carried across a branch of the River Severn on a single-track girder bridge with an opening span to facilitate the unobstructed movement of river traffic. The line was double tracked for much of its length, with a section of single line on the approaches to Llanthony Goods Yard. In its final years of operation, the docks branch was worked as two single lines, the up line being used as a single-running line, while the down line functioned as a siding. The upper picture shows Over Junction, looking west towards Fishguard, while the lower view shows Class 20 locomotive No. 20115 on the Gloucester Docks on branch with the F&W Railtours Severncider 2 railtour on 30 June 1985.

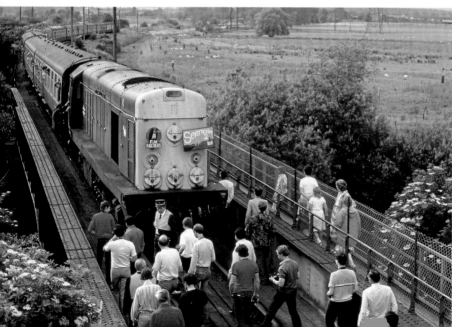

Gloucester – Over Junction

Right: Class 66 locomotive No. 66213 passes the site of Over Junction while hauling the 11.41 a.m. Tavistock Junction to Bescot China Clay working on 29 March 2008. The Gloucester Docks branch diverged southwards behind the bushes on the left.

Below Left: Class 170 unit No. 170109 passes the site of Over Junction with the 7.45 a.m. Cardiff Central to Nottingham CrossCountry service on 29 March 2008.

Below Right: Deltic Class 55 locomotive No. 55022 *Royal Scots Grey* passes the site of Over Junction with the 8.00 a.m. Pathfinder Tours Cardiff Central to Llandrindod Wells Heart of Wales Explorer railtour on 29 March 2008. The Ledbury route was closed with effect from 13 July 1959, the last trains being run on Saturday 11 July. Freight trains ran over the southern end of the route as far as Dymock until 1964.

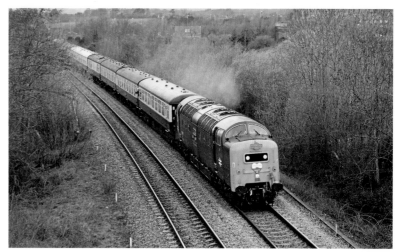

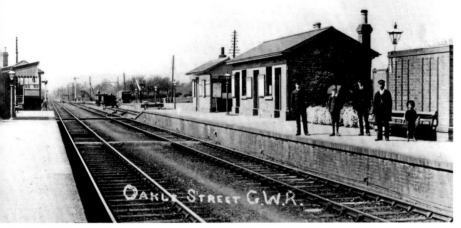

Oakle Street

Heading west-south-westwards along a virtually dead-straight section of track, with the winding River Severn visible away to the left, trains reach the site of Oakle Street station (119½ miles) – a simple, two-platform stopping place, which had first been opened on 19 September 1851. An incidental reference in a company minute book mentions that Oakle Street was 'made as a temporary station by way of an experiment' by I. K. Brunel, while some sources claim that the station was closed around 1856. If this was indeed the case the closure must have been merely temporary because, in March 1866, the minute books refer to an intended closure in that same year. Oakle Street had nevertheless reappeared in the timetables by 1870, and the station remained in use until the run-down of the railway system during the 1960s.

The main building on the up (eastbound) platform was a single-storey, stone-built structure, with a low-pitched slated roof and rectangular door and window apertures. A diminutive timber building sited to the west of the main block provided additional accommodation, and appeared to have been a somewhat later addition of around 1870. The up and down platforms were linked by barrow crossings, while a minor road was carried across the railway on a shallow-arched stone overbridge at the east end of the station. The single-siding goods yard on the up side was equipped with coal wharves, cattle pens and a weigh-house, together with a 1 ton 10 cwt hand crane.

The station issued around 9,000 tickets per annum during the first decade of the twentieth century though, by the early 1930s, sales of ordinary tickets had fallen to approximately 2,500 a year, and by 1938 this meagre figure had decreased still further to just 1,983 ordinary bookings and seven season tickets. The upper photograph shows Oakle Street around 1912, while the lower view dates from the 1960s.

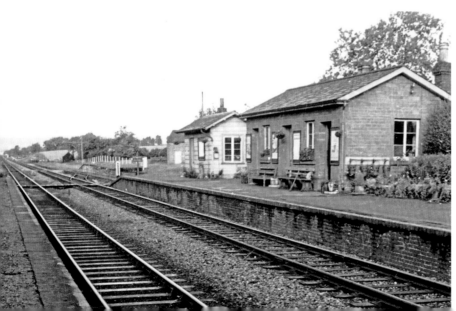

Oakle Street

Right: With cows enjoying the sunshine in the adjacent meadows, Class 170 unit No. 170102 passes Churcham, near Oakle Street, with the 9.45 a.m. Cardiff Central to Nottingham CrossCountry service on 4 May 2010. This photograph was taken from an isolated footbridge in the fields near Churcham, which gives excellent views of eastbound trains, with a clear view for several miles, way past Oakle Street, and the hills on the northern edge of the Forest of Dean visible in the background.

Below Left: Class 66 locomotive No. 66094 is pictured at Churcham, near Oakle Street, on 6 April 2011 while hauling the 3.53 a.m. Redcar to Margam coal train.

Below Right: Class 60 locomotive No. 60074 *Teenage Spirit* passes Churcham with the 5.05 a.m. Robeston to Westerleigh Murco oil train on 4 May 2010. After a period of haulage by pairs of Class 66s, this working later reverted to Class 60 haulage, and No. 60074 become a regular performer.

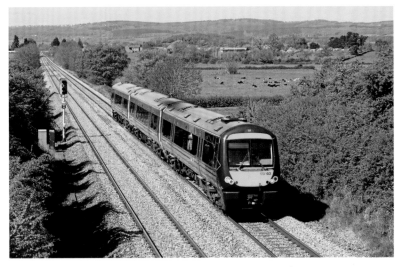

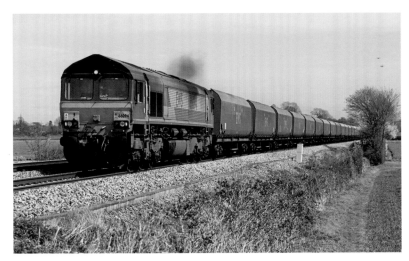

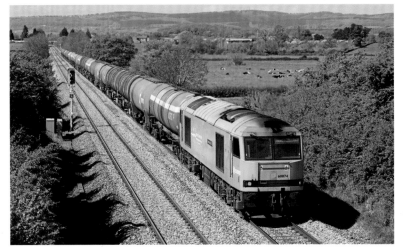

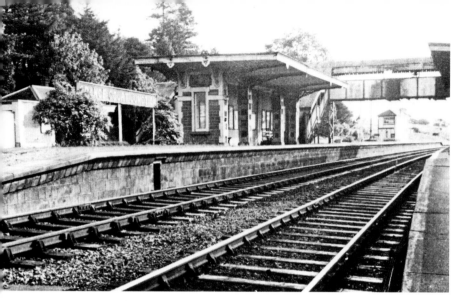

Grange Court

From Oakle Street the route continues west-south-westwards across level terrain for a distance of about two miles. There are two level crossings on this section, Ley Crossing being less than a mile beyond the station, while Broken Cross Crossing is a only short distance further on. Both of these crossings were formerly worked by gatekeepers. Having passed over Broken Cross Level Crossing, trains soon reach the site of Grange Court station (121½ miles from Paddington). Opened in 1855, this station was the junction between the Gloucester & Dean Forest Railway and Hereford, Ross & Gloucester line, and it featured a relatively spacious track layout with four through platforms – the up and down main line platforms being situated on the south side of the station, while the Hereford platforms were to the north. The platforms were linked by a Great Western covered footbridge, and a minor road was carried across all four lines on a double-arched overbridge to the west of the platforms. The Hereford route diverged from the South Wales main line by means of a double track junction which was situated immediately to the east of the platforms.

The main station building was on the down side and there was an additional waiting room on the centre platform – which was an island sited between the up main and down branch lines. A much smaller waiting room was available on the up branch platform on the north side of the station. The main buildings were of obvious Brunelian design, the building on the island platform being a particularly striking example with a distinctive flat roof, as shown in the upper photograph. The subsidiary building on the up branch platform was, in contrast, a standard Great Western hip-roofed structure containing additional waiting room and toilet facilities. The lower photograph shows the branch platforms during the BR era around 1963.

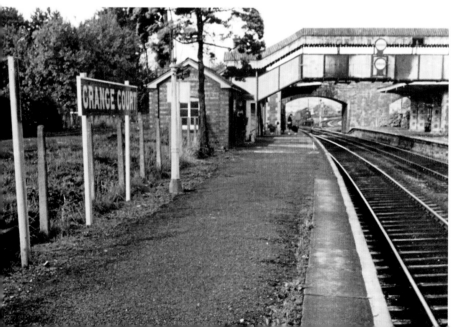

Grange Court

Right: A further view of Grange Court during the 1960s, looking west towards Fishguard. This station was closed with effect from Monday 2 November 1964, when passenger services were withdrawn from the Hereford, Ross & Gloucester route.

Below Left: Permanent way men take a break from their labours on the disused up loop at Grange Court as Class 170 unit No. 170110 passes through this closed station while forming the 8.08 a.m. Nottingham to Cardiff Central CrossCountry service on 14 January 2011. Note the dead straight track heading off into the distance.

Below Right: Class 170 units Nos 170521 (leading) and 170113 run cautiously over newly laid track at Grange Court on 20 August 2012, as they work the 10.45 a.m. Cardiff Central to Nottingham CrossCountry service. This view clearly shows the course of the abandoned line to Ross-on-Wye and Hereford, still visible as a gap in the bushes nearly half a century after closure.

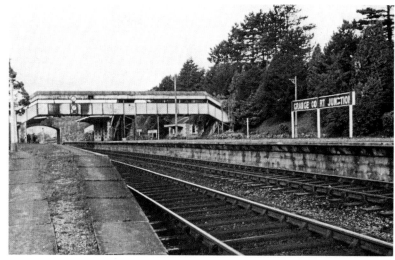

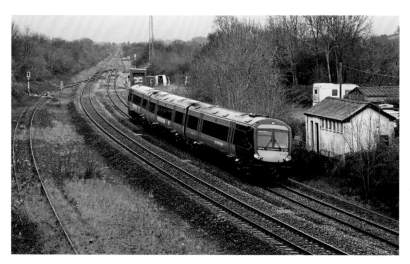

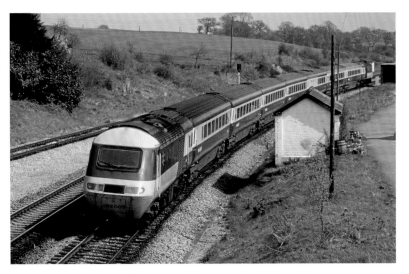
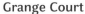

Grange Court

Left: HST-power car No. 43010 leads the diverted 10.15 a.m. Paddington to Swansea InterCity service past Grange Court on 18 April 1982. The train's normal route via the Severn Tunnel had been closed for engineering works and, in consequence, South Wales services had been rerouted via Gloucester and the Stroud valley line.

Bottom Left: The hills in the background are shrouded in low cloud and fog, but Class 60 locomotive No. 60010 manages to find a small patch of sunshine as it passes Broken Cross, near Grange Court, with the 5.05 a.m. Robeston to Westerleigh Murco oil train on 3 September 2010.

Below Right: On its second day in operational service on the heavy South Wales oil trains after arriving from its repaint at Toton, Class 60 locomotive No. 60011 rounds the curve at Grange Court with the 5.05 a.m. Robeston to Westerleigh Murco bulk-oil trains on 14 January 2011. The locomotive had recently been repainted at Toton in DB Schenker red livery, and the buffers were still silver when this photograph was taken.

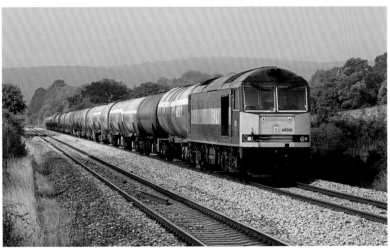

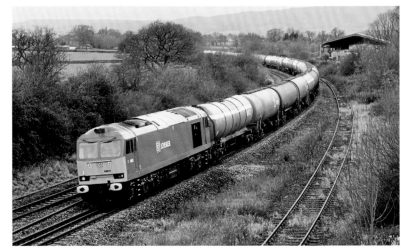

Newnham

Continuing south-westwards, trains pass the site of an abandoned halt at Westbury-on-Severn (123 miles), which was opened by the GWR on 9 July 1928 and closed with effect from 10 August 1959. Newnham (125 miles), two miles further on, was a more important stopping place, which was opened on 19 September 1851 to serve an attractive Severnside town. Up and down platforms were provided here, together with a single-siding goods yard on the down side. In architectural terms, Newnham station exhibited a mix of styles – the down side building being a small, gable-roofed structure of obvious 'Brunelian' design, whereas the building on the up platform was a later Great Western addition. The platforms were extended in 1907 and a dead-end bay was inserted on the down side for use by Cinderford branch services.

The upper view is looking east towards Paddington in the early years of the twentieth century, the down side bay platform being visible to the right, while the standard Great Western building on the up platform can be seen beyond the footbridge. The lower photograph was taken from an elevated position above the up platforms, and it shows a push-pull train in the Cinderford branch bay. Sadly, the Cinderford line was closed with effect from 1 November 1958, while Newnham station was itself closed with effect from 2 November 1964.

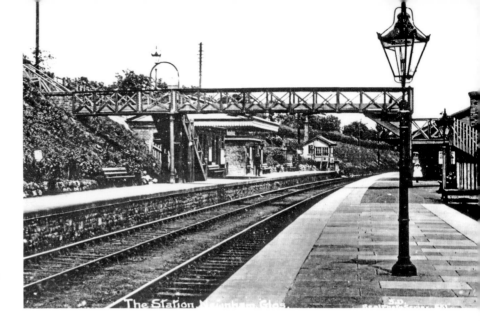

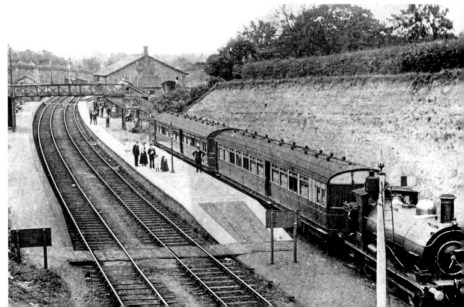

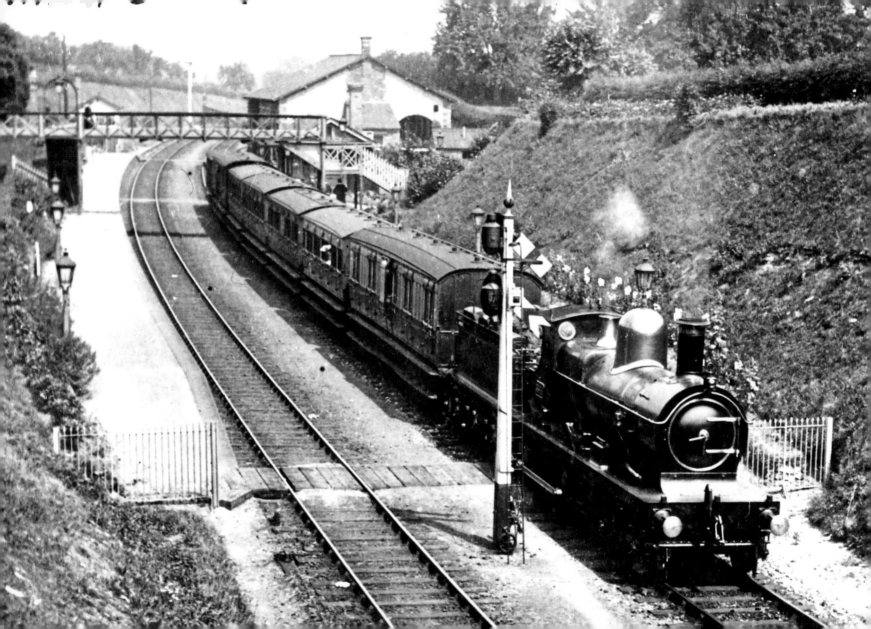

Newnham

Right: A general view of Newnham station.

Below Left: Class 150 unit No. 150259 emerges from the southern portal of Newnham tunnel while forming the 1.45 p.m. Cheltenham to Maesteg Arriva Trains Wales service on 20 August 2012. The tunnel, 232 yards in length, is situated a short distance to the west of the former station.

Below Right: Running ten minutes late, ex-Southern Railway Merchant Navy Class 4-6-2 No. 35028 *Clan Line* emerges from Newnham Tunnel with the 8.45 a.m. Steam Dreams Victoria to Cardiff Central (via Gloucester) Cathedrals Express railtour on 20 August 2012.

Opposite: Newnham

A main line stopping train waits alongside the down platform, the locomotive being a 3521 Class 4-4-0. This photograph must have been taken before 1907, as the Cinderford branch bay platform has not yet been installed.

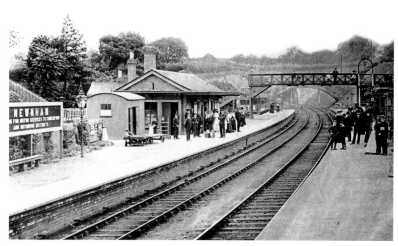

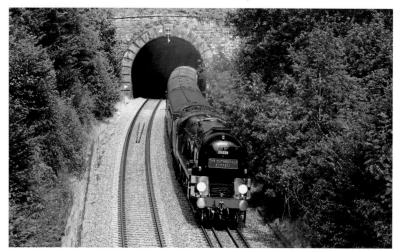

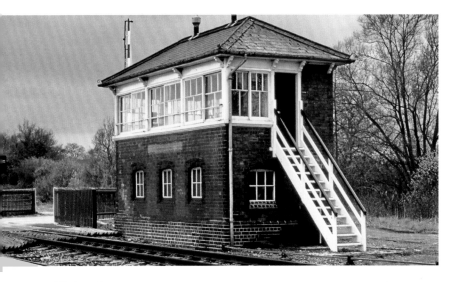

Left: Awre

Curving onto a southerly alignment, down trains pass the site of Awre station (128¼ miles). This wayside stopping place was opened on 1 April 1869, and closed with effect from 10 August 1959. Awre was the junction for the ill-fated 'Forest of Dean Central Railway', which was authorised in 1856 as a branch from New Fancy Colliery to Brimspill. The line, which never carried passengers, was opened in 1868, but it was subsequently cut back to Blakeney. This obscure branch was closed to regular traffic in 1959, although part of the route remained in situ thereafter for wagon storage purposes. The photograph, taken on 3 April 1982, shows Awre Signal Box on 3 April 1982. The cabin was reduced to the status of a crossing ground frame in 1969. Lifting barriers, monitored from Lydney, were installed in 1973, but the box was retained as a permanent way hut.

Right: Awre

Class 25 locomotive No. 25327 passes through Awre with what appears to be a very late-running diverted 5.26 p.m. Ince to Carmarthen UKF fertiliser train on 3 April 1982. No. 25327 was the final Class 25 to be delivered in April 1967, its pre-TOPS number being D7677. The locomotive was withdrawn in February 1984, and after being stored at Crewe and Swindon, it was moved to Vic Berry's scrap yard at Leicester in 1987 before being broken up in March 1988.

Opposite: Awre

Ex-LMS Jubilee Class 4-6-0 No. 45596 *Bahamas* runs alongside the River Severn at Purton, near Awre, at the head of the 7.13 a.m. Pathfinder Tours Trowbridge to Crewe Welsh Marches Express railtour on 23 April 1994. It may appear, at first glance, that the train is going in the wrong direction, and indeed this enthusiasts' special was following a very convoluted route, heading northwards initially via Bristol and Cheltenham to Worcester, before returning to Gloucester and on to Severn Tunnel Junction (hence the picture here). It then proceeded northwards via Pontypool and Hereford to Crewe, *Bahamas* being used between Worcester and Crewe.

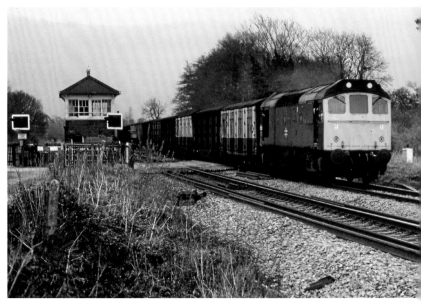

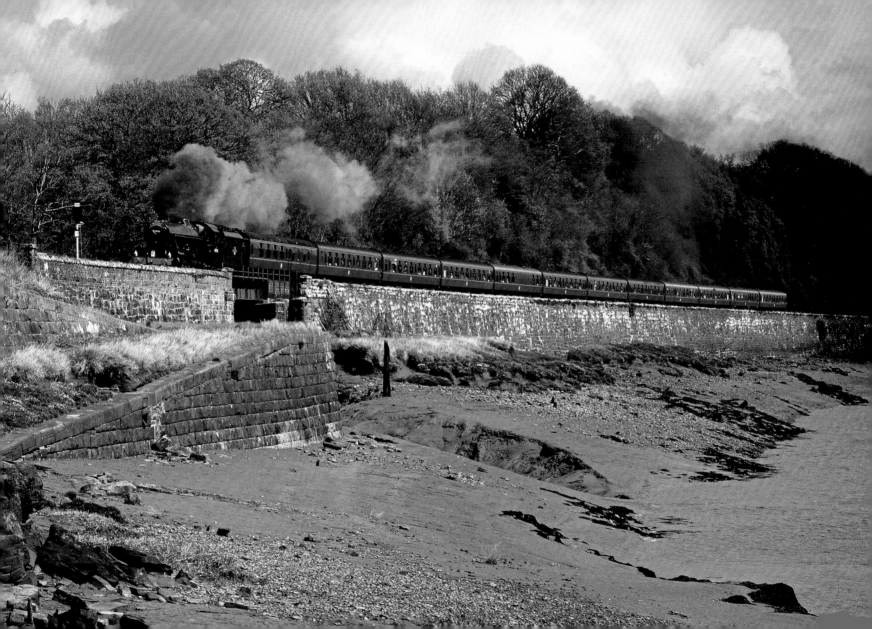

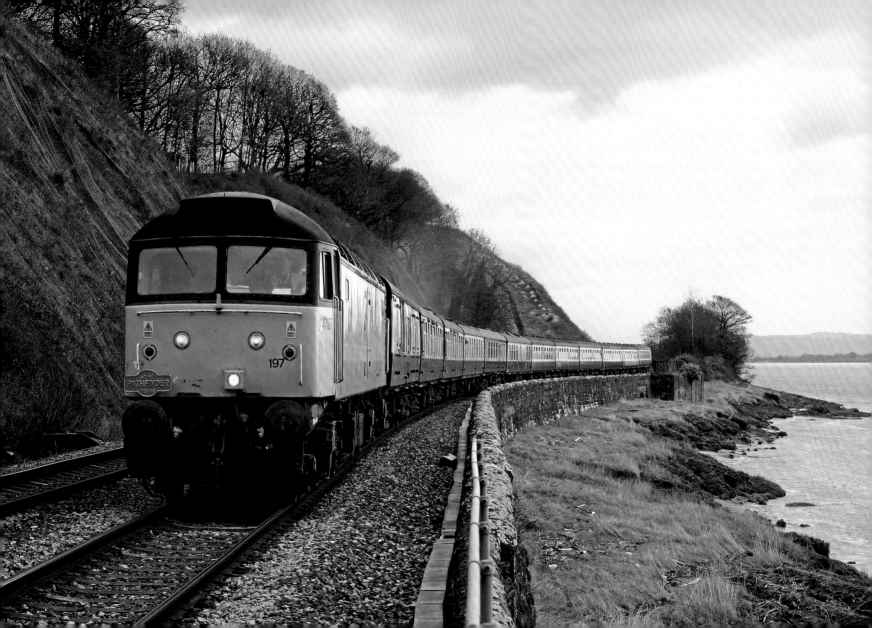

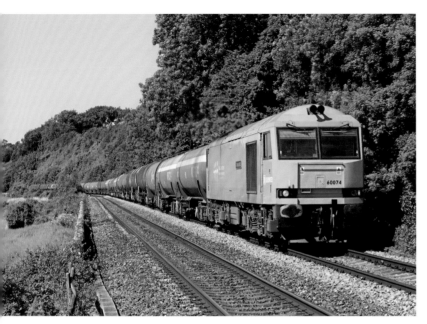

Right: Gatcombe

Class 170 unit No. 170635 skirts the River Severn at Gatcombe with the 9.00 a.m. Cardiff Central to Nottingham Central Trains service on 7 February 2004. The photographed was taken from a footpath crossing which leads straight down to the water's edge. Note the very steep bank behind the line, which had recently been cleared of vegetation.

Opposite: Gatcombe

Class 47 locomotive No. 47197 runs alongside the River Severn at Gatcombe with the 6.26 a.m. Pathfinder Tours Crewe to Margam Valley Vostock railtour on 7 February 2004.

Left: Gatcombe

Resuming its south-westerly heading, the route follows the shoreline of the Severn Estuary – the South Wales main line having many affinities with the waterside sections of the South Devon route. A wayside station was in use at Gatcombe from 1852 until 1869, when it was replaced by nearby Awre. This short-lived stopping place was 130½ miles from Paddington, and it was sometimes referred-to as 'Gatcombe (Purton Passage)'. The accompanying photograph shows Class 60 locomotive No. 60074 *Teenage Spirit* running alongside the River Severn at Gatcombe with 5.10 a.m. Robeston to Westerleigh Murco oil train on 2 June 2009. Even on a weekday a number of photographers had tuned up at this remote spot for this train, which resulted in a road tanker driver having to wait, as photographer's cars were preventing him turning round!

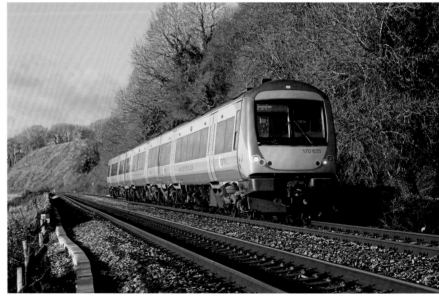

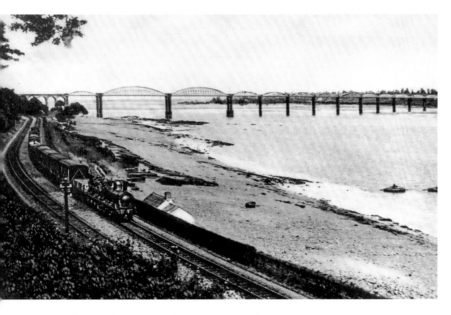

Right: Lydney Junction

A connection between the GWR and S&WJR routes sited immediately to the east of Lydney Junction station enabled diverted main line workings to make use of the Severn Bridge when the Severn Tunnel was under repair. Opened on 19 September 1851, Lydney Junction is a two-platform station with a level crossing immediately to the west. Prior to rationalisation, the facilities here had included siding connections to Lydney Docks and the Lydney Tinplate Works, together with a short branch to the nearby S&WJR station at Lydney Town, which had been opened in 1875 and rebuilt on a new site beside the Great Western station in 1871. The two stations were officially combined in 1955 but, in the event, this arrangement was destined to be short-lived, as the former S&WJR station was closed in October 1960, following the Severn Bridge disaster. Happily, a section of the former S&WJR between Lydney Junction and Parkend has been revived as a 'heritage' railway.

Left: Lydney – The Severn Bridge

Continuing south-westwards, trains reach Lydney Junction (133½ miles), at which point the main line formerly joined the Severn & Wye Joint Railway – a joint GWR and Midland (later LMS) undertaking that operated around 39 miles of track, mainly in the Forest of Dean. The S&WJR 'main line' extended from Berkeley Road, where it connected with the Midland Railway, to Lydney Junction – the River Severn being crossed by a massive viaduct with thirty-four spans and a total length of 4,162 feet. Having crossed this mighty structure, the Severn & Wye route ran parallel to the main line before the two routes reached Lydney. The Severn Bridge was damaged on the night of 25 October 1960 when two petrol-carrying barges collided in thick fog, and then struck Pier No. 17 with such force that it collapsed, bringing down two bowstring girders onto the barges and igniting the volatile cargoes that they were carrying. The bridge was subsequently dismantled, this melancholy task being completed by 1970.

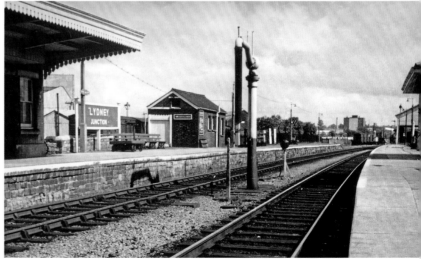

Lydney Junction

Right: Lydney Junction was in many ways the operational centre of the Forest of Dean system, its importance being underlined, in steam days, by the presence of a motive power depot on the up side of the running lines. The main shed building was a 3-road structure which, from its appearance, probably dated from Severn & Wye days. The usual coaling and watering facilities were available, but there was no turntable, the normal allocation being composed of tank locomotives. In 1947 Lydney housed nineteen engines, most of these being 2021 Class pannier tanks, which were widely-used in the Forest of Dean area.

Below Left: Class 47 locomotive No. 47815 *Great Western* approaches Kears Wood near Lydney with the 9.35 a.m. Cardiff to Gloucester rugby special on 17 March 2007. Sister engine No. 47812 was at the rear of the train.

Below Right: Class 50 locomotive No. 50049 *Defiance* (masquerading as No. 50012 *Benbow*) approaches Lydney with the 7.27 a.m. Goodwick County Council Tyseley to Fishguard Harbour Fishguard Centenary Special charter on 19 August 2006.

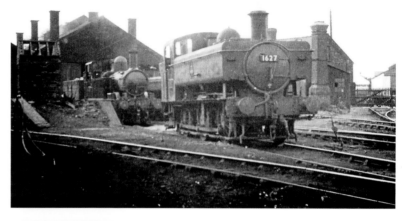

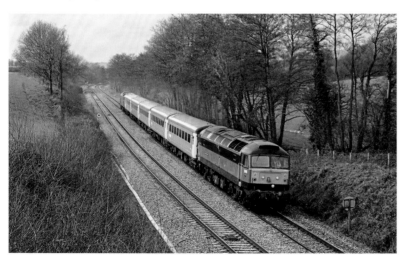

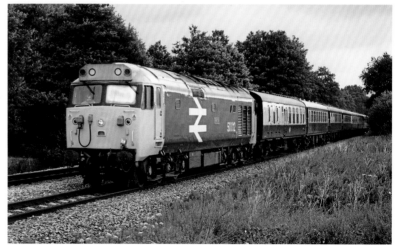

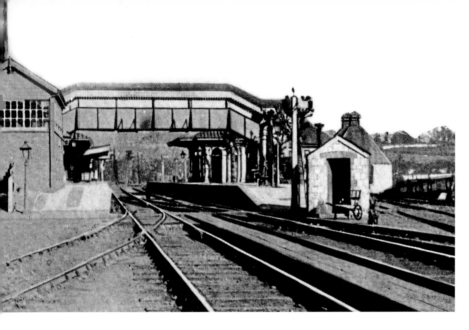

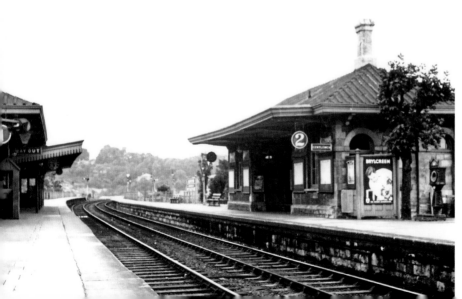

Chepstow

Chepstow (141½ miles) was opened by the South Wales Railway on 18 June 1850 and, in its first months of operation the station served as the terminus of a 75 mile line from Landore – there being no through communication with Gloucester until the completion of Chepstow Bridge some two years later. Chepstow became a junction on 1 November 1876, when the Wye Valley Railway was opened throughout to Monmouth. The station was aligned from north to south, with its main buildings on the up side and an island platform on the down side. The up and down sides of the station were linked by a typical GWR roofed footbridge, while the goods yard was sited to the south of the platforms on the up side.

The main station building was a classic Brunelian 'chalet' type structure, with a low-pitched hipped roof and Italianate architectural features. A matching building was provided on the down platform, and a standard GWR roofed footbridge linked the two sides of the station. The signal cabin, which was sited on the up platform, was a standard Great Western hipped roof structure, while the nearby goods shed was of obvious Brunelian design.

The upper photograph shows Chepstow station during the early 1900s, while the lower view is looking eastwards along the up platform, probably around 1930. Photographic evidence suggests that the station buildings were jacked-up and physically moved in 1877 in order to provide sufficient room for raised platforms and the Wye Valley branch bay – this delicate task being carried out by Cuthbert Whalley, a local contractor.

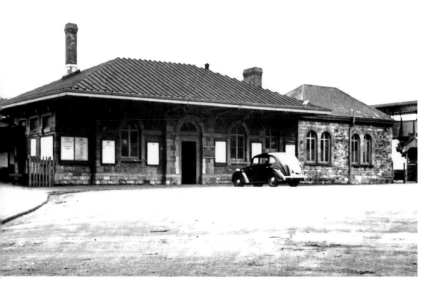

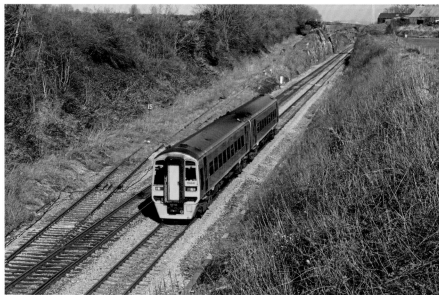

Left: **Chepstow**

A detailed view of the archetypal 'Brunelian' station building on the up side. Hip-roofed 'chalet' style buildings of this type were normally erected at stations of medium importance such as Chepstow and Ferryside, whereas less important wayside stations on the SWR route, such as Oakle Street, Magor, Portskewett and Awre, were equipped with gable-roofed station buildings of less flamboyant design. The up side station building at Chepstow became a Grade II-listed building in 1974. Although buildings of this type were designed by Brunel, they were probably erected under the supervision of his assistants, such as R. P. Brereton or Lancaster Owen; it nevertheless seems sensible to describe them as 'Brunelian' structures, as they conform to designs originally conceived by Brunel himself.

Right: **Chepstow**

Class 158 unit No. 158841 passes Wye Valley Junction, to the east of the station, with the 1.45 p.m. Cheltenham to Maesteg Arriva Trains Wales service on 17 March 2007. The disused and overgrown Wye Valley route can be seen climbing up above the main line to the left of the train. The Wye Valley branch was closed with effect from 5 January 1959, and as this was a Monday the last passenger trains ran on Saturday 3 January. Goods traffic was carried between Chepstow and Monmouth for a further five years, but these residual services came to an end in January 1964, after which most of the line was lifted, apart from a 4-mile section at the Chepstow end of the route that was retained until 1990 in connection with quarry traffic from Tintern Quarry.

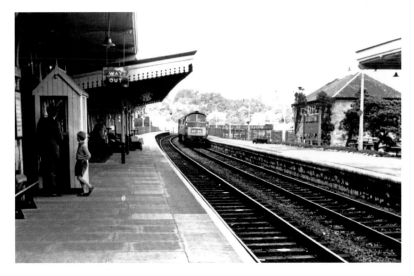

Chepstow

Left: A general view of Chepstow station during the British Railways era, around 1964, looking east towards Paddington. A Class 52 diesel-hydraulic locomotive is passing through the station with a down freight working.

Below Left: A view of the down side station building during the BR period, looking west towards Fishguard. The station name board reminds travellers that Chepstow was the 'Junction for the Wye Valley Line'.

Below Right: This final view of Chepstow dates from around 1969 – by which time all reference to the Wye Valley branch had been removed from the station name boards. Chepstow remains in operation as part of the national railway system, and much of its historic infrastructure has survived – the main station building having found a new role as a cafe and coffee shop.

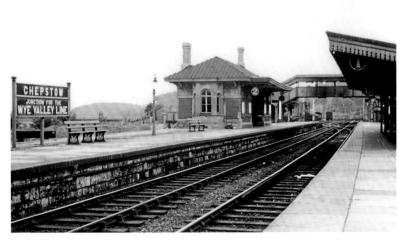

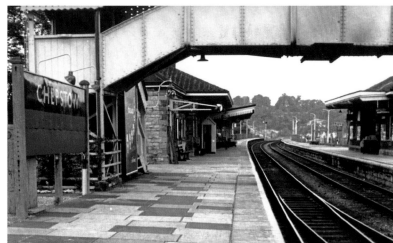

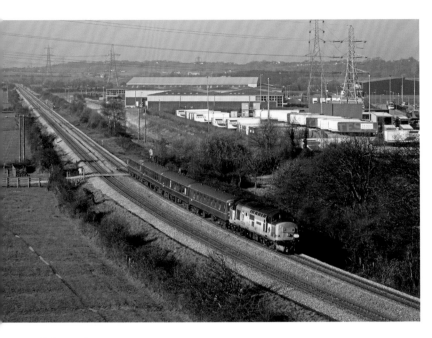

Left: Chepstow

Opened in 1966, the Severn Road Bridge carries the M48 motorway high above the River Severn between Beachley and Aust. The bridge incorporates footpaths and cycle tracks on both sides, and these serve as excellent vantage points for photography of the South Wales main line, as exemplified by this almost-aerial shot of Class 37 locomotive No. 37412 *Driver John Elliot* passing beneath the bridge at the head of the 8.15 a.m. Pathfinder Tours Cardiff Central to Newquay 'Cornish Raider' rail tour on 30 March 1996. Northwards-looking shots from the Severn Bridge are relatively well-known, but southwards-looking photographs are less common – mainly because the sun only shines in the 'right' direction during the early morning (moreover, the recently-erected Tesco distribution depot has done little to improve the view).

Right: Chepstow

With the muddy waters of the River Wye visible in the background, Class 150 unit No. 150102, in ex-works condition, is about to pass under the Severn Road Bridge with the 1.15 p.m. Birmingham New Street to Cardiff Central Trains service on 3 September 1999. The houses in the background are in the village of Beachley, which is situated on a peninsula between the mouth of the River Wye and the River Severn. This narrow strip of land was, at one time, the site of an extensive, rail-linked shipyard, which was opened in 1917, during the First World War, and closed just two years later; the Beachley Shipyard branch left the main line at Beachley Junction, about half-a-mile to the east of Wye Valley Junction.

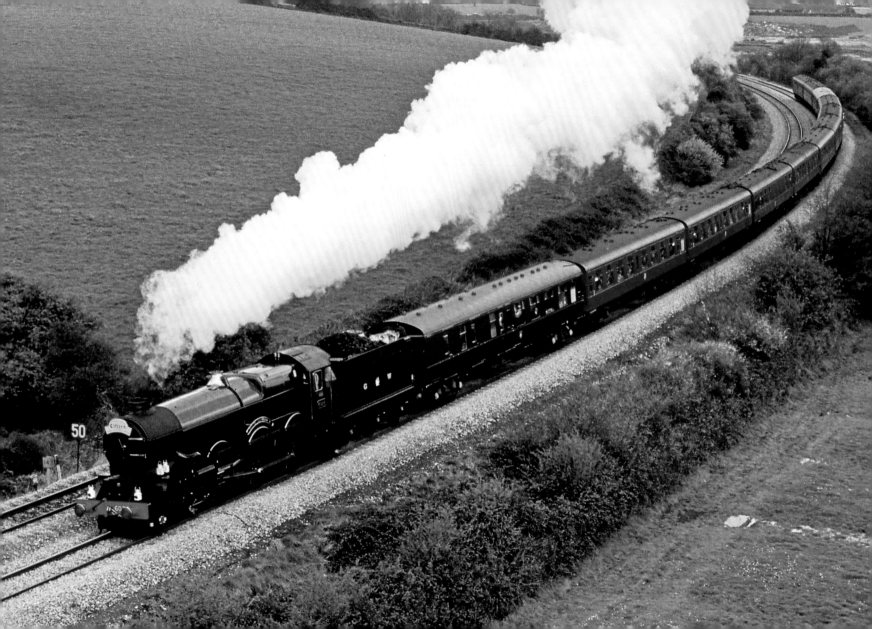

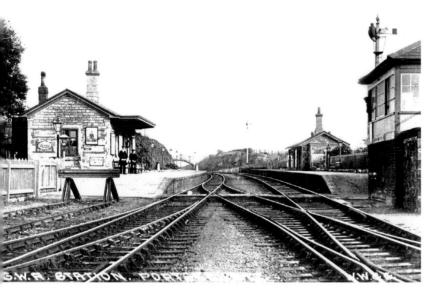

Right: Portskewett

A further view of Portskewett station, looking west towards Fishguard during the early years of the twentieth century. The Portskewett Pier branch joined the down main line by means of a trailing connection that was sited immediately to the west of the platforms. It then ran alongside the down platform which, prior to 1886, had been an island with tracks on either side. The northern extremity of the Pier branch was retained as a siding after the closure of the Pier, but the western side of the down platform was then fenced off. Portskewett station remained in use until the 1960s but, sadly, it was listed for closure in the notorious Beeching Report, and its passenger services were withdrawn with effect from 2 November 1964.

Opposite: Portskewett

Viewed from the Severn Bridge, King Class 4-6-0 No. 6024 *King Edward I* rounds the curve from Chepstow with the 9.00 a.m. Pathfinder Tours Worcester to Gloucester 'Severn-Wye' railtour on 12 April 1993.

Left: Portskewett

Maintaining its south-westerly heading, the route continues to the site of Portskewett station (145¾ miles). This wayside stopping place was opened on 19 June 1850 and rebuilt on a new site in October 1863 – the resiting being necessary in connection with the opening of a short broad-gauge branch to Portskewett Pier and the New Passage Steam Ferry, which remained in use until the opening of the Severn Tunnel in 1886. The station boasted a typical 'Brunel' style gable-roofed station building on the up (eastbound) platform and a smaller building on the down side. The main building was a single-storey, stone-built structure, with a low-pitched slated roof as shown in the accompanying photograph. The up and down platforms were linked by barrow crossings at each end, and a minor road was carried across the railway on a shallow-arched stone overbridge at the east end of the station.

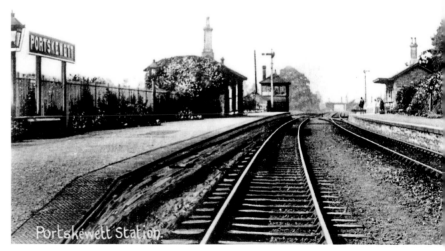

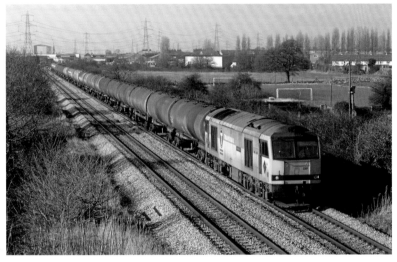

Portskewett

Left: With rust-coloured stains on its roof giving clear evidence of its recent use on the Port Talbot to Llanwern iron-ore workings, Class 60 locomotive No. 60081 *Bleaklow Hill* passes Portskewett with the 5.40 a.m. Robeston to Westerleigh Murco oil train on 27 February 1996.

Below Left: Birmingham RC&W Company Class 118 set 470, comprising motor second No. 51328 and motor brake second No. 51313, passes Portskewett while forming the 10.54 a.m. Newport to Chepstow service on 4 September 1986.

Below Right: Sunshine and shade at Portskewett on 20 September 2008 as Class 158 unit No. 158823 passes with the 9.17 a.m. Maesteg to Cheltenham Arriva Trains Wales service. This is, on the face of it, an unlikely through working, and one wonders how many passengers actually travel the full length of the route? The field on the right, known as 'Harold's Field' is said to have been the site of an Anglo-Saxon hunting lodge built in 1065 by Harold Godwinson, later to become King Harold, after he had defeated the Welsh.

Caldicot Halt

Right & below left: Turning onto a westerly alignment, down workings reach Caldicot (147¾ miles), an unstaffed stopping place that was opened by the GWR on 12 September 1932. Caldicot Halt was listed for closure in the Beeching Report but, incredibly, it was reprieved by Ernest Marples who refused to give his consent – a very rare example of the transport minister refusing to sanction a closure. The wooden platforms and Great Western 'pagoda' shelters have now been replaced by more substantial platforms and glazed waiting shelters.

Below Right: The nearby Caldicot Junction Signal Box controlled access to the Sudbrook branch and the Caerwent branch – the Sudbrook line having once served a Severn Tunnel pumping station, while the Caerwent branch gave access to a Second World War depot that remained in use as a storage facility during the Cold War era.

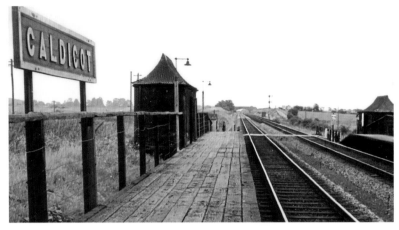

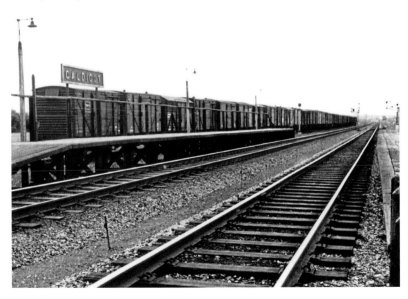

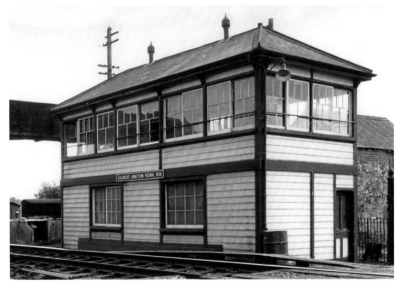

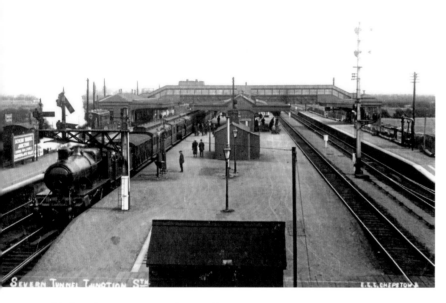

Left: Severn Tunnel Junction

As trains hurry westwards, they run parallel to the Severn Tunnel route, which climbs up beside the earlier South Wales line and emerges into daylight on the north side of the original line before both routes run into Severn Tunnel Junction station (148¾ miles). Opened on 1 December 1886, Severn Tunnel Junction formerly had four through platforms and a terminal bay, but the number of platforms has now been reduced to four. The platforms are still linked by a Great Western lattice girder footbridge, but most of the station buildings have been demolished. In their place, simple waiting shelters afford minimal comfort for waiting travellers, although a small ticket office is available on the up side. The photograph, taken around 1910, is looking eastwards from the road overbridge at the west end of the platforms, the main station building – a standard GWR hip-roofed structure – being visible to the left.

Right: Severn Tunnel Junction

Prior to rationalisation, Severn Tunnel Junction had been equipped with extensive siding accommodation, these facilities being used to marshal coal trains and provide berthing for freight trains awaiting paths into England – especially those scheduled to pass through the 4½ mile Severn Tunnel. The photograph is looking towards Fishguard from the east end of the station around 1967, the bay platform being visible in the foreground.

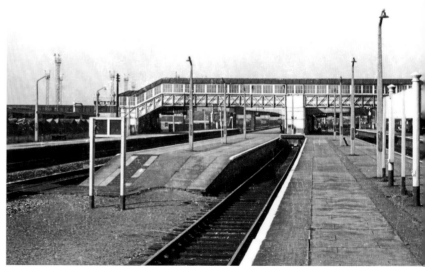

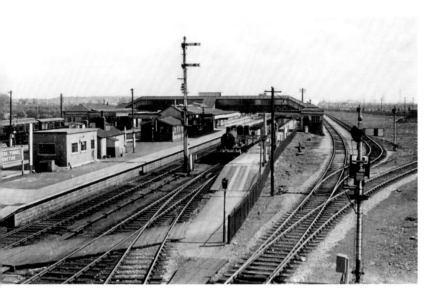

Right: Severn Tunnel Junction

Class 50 locomotive No. 50046 *Ajax* passes through Severn Tunnel Junction station with a short rake of recovered track panels on 5 June 1989. This locomotive was relegated to engineering duties for a period of two years, having been demoted from passenger work. The train is standing on the down main line, the up main line being visible to the left of the locomotive, while the up and down Severn Tunnel lines can be seen on the extreme left of the picture.

Left: Severn Tunnel Junction

A view from the road overbridge, looking east towards Paddington during the early British Railways period, probably around 1956. A Severn Tunnel Junction motive power depot, was sited to the west of the platforms on the up side. Coded '86E' during the British Railways period, the shed was opened in 1908 and enlarged in 1933, when the number of shed roads was increased from four to six. The usual range of accommodation was provided, including a raised coaling stage, a repair shop, offices, mess rooms and a turntable. Severn Tunnel Junction had an allocation of around eighty locomotives during the early BR period, many of these being 28XX Class 2-8-0s, 42XX Class 2-8-0Ts and 72XX Class 2-8-2Ts for heavy freight work, although these were also a large number of 'new' 31XX Class 2-6-2Ts – these powerful small-wheeled prairie tanks being used as banking engines on the Severn Tunnel line.

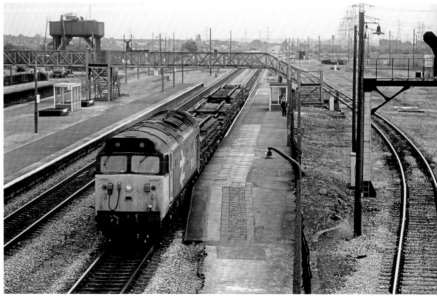

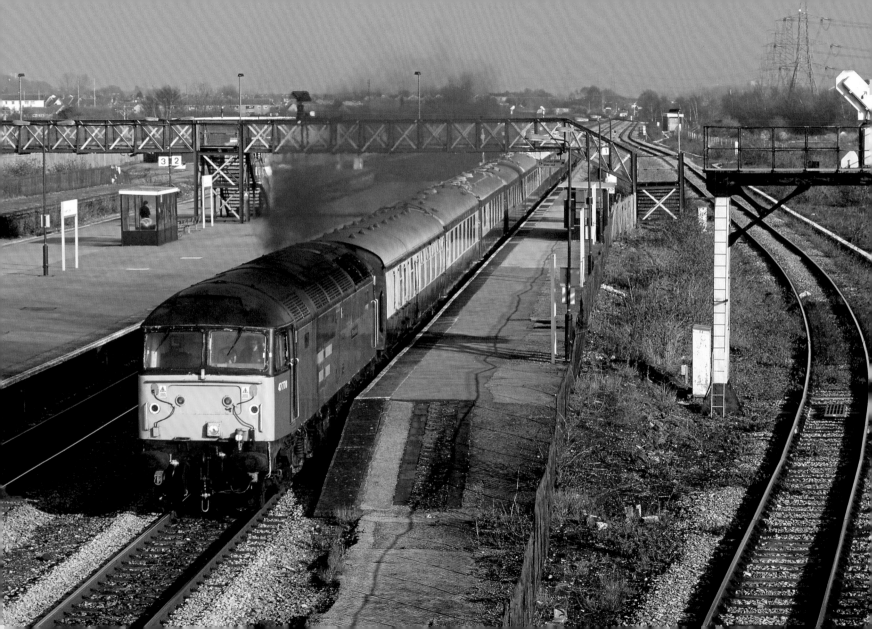

Severn Tunnel Junction

Right: Superpower at Severn Tunnel Junction as Class 56 locomotives
Nos 50015 *Valiant* and 50010 *Monarch* arrive with the 10.17 a.m. Brighton
to Cardiff service to pick up just six passengers on 30 June 1985.

Below Left: Passing a patch of buddleia bushes, an HST set headed by
power car No. 43132 takes the Severn Tunnel line at Severn Tunnel Junction
with the 8.15 a.m. Cardiff Central to Paddington First Great Western service
on 14 August 2004. The fenced enclosures mark the site of the former
Severn Tunnel Junction motive-power depot, while the overgrown wasteland
on the extreme left of the picture is the site of former freight facilities.

Below Right: Class 56 locomotive No. 56043 passes through a deserted
Severn Tunnel Junction station on 15 April 1991 with the 9.20 a.m.
Mondays-only Fawley to Clydach LPG tank train.

Opposite: Severn Tunnel Junction

Class 47 locomotive No. 47770 *Reserved* accelerates through Severn Tunnel
Junction station with the 12.15 p.m. Victoria to Cardiff VSOE rugby special
on 22 February 2003. Locomotives allocated to the Rail Express Systems
(RES) train operating company were given names beginning with 'Res'.

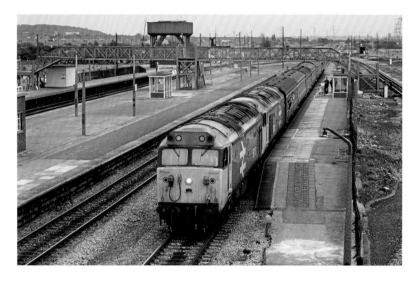

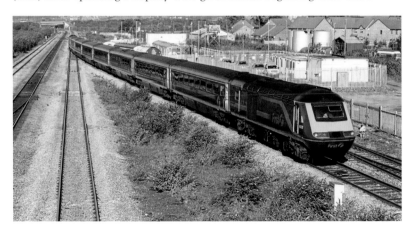

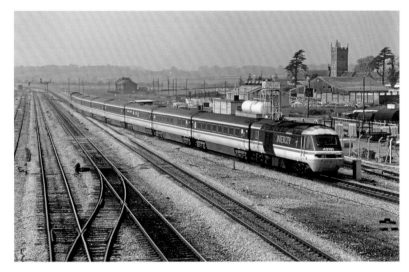

Severn Tunnel Junction

Left: An HST set headed by power car No. 43121 sweeps past the desolate remains of Severn Tunnel Junction Yard on 15 April 1991, as it prepares to descend into the tunnel with the late-running 11.32 a.m. Swansea to Paddington *St David Pullman*, The former depot's fueling point is one of the few surviving indications in this picture of the importance of the once-busy freight centre.

Below Left: With Rogiet Church clearly visible in the background, the last rays of the setting sun illuminate Class 66 locomotive No. 66156 as it passes through Severn Tunnel Junction station with the 8.33 p.m. Burngullow to Warrington china-clay slurry train on Saturday 22 February 2003.

Below Right: HST power car No. 43180 passes the site of Severn Tunnel Junction motive power depot with the 8.29 a.m. Swansea to Paddington First Great Western service on 20 September 2006. Whereas in previous years the area behind the HST would be occupied by lines of Class 37 and 47 locomotives on a weekend, today a solitary Class 66 (No. 66005) sits at the entrance to the former depot.

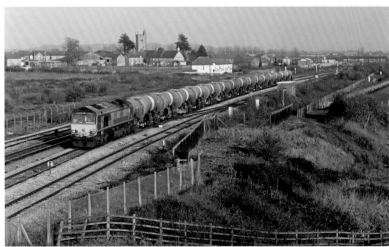

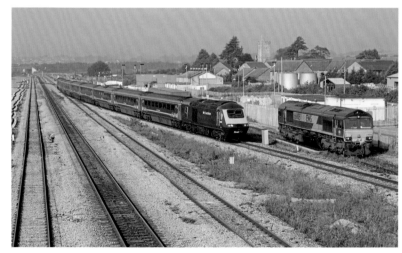

Undy Halt

Now heading due west, the route continues along virtually dead-level alignments as it follows the South Wales coastal plain. This section of line was quadrupled to cater for heavy wartime traffic in 1941 – the four tracks being continued as far west as Newport, a distance of 9 miles. Undy (150½ miles) was the site of a simple halt that was opened by the GWR on 11 September 1933 and closed with effect from 2 November 1964. The trestle platforms here were of sleeper construction, while the waiting shelters were austere, brick-built structures, as shown in the accompanying photographs. Although Undy Halt was situated on a quadruple-tracked section of the line it had only two platforms – there being no platforms on the up and down Relief lines.

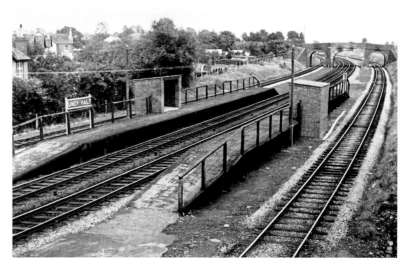

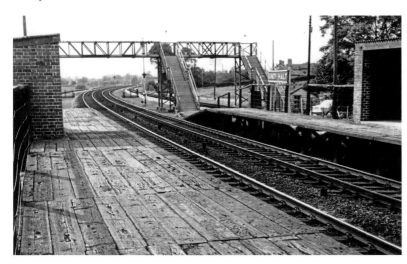

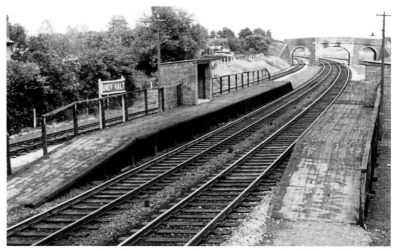

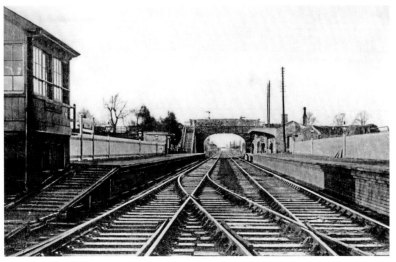

Magor

Left: The next station at Magor (151¼ miles), a short distance further on, was opened in October 1851. It was, for many years, a two-platform stopping place with up and down platforms for passenger traffic and a small goods yard that was able to deal with coal, livestock and general merchandise traffic. The main station building was on the up side, and a minor road was carried across the line on a single-arch overbridge at the west end of the platforms.

Below Left: Another view of Magor station during the early 1900s, looking east towards Paddington.

Below Right: The track layout at Magor was altered when the line was quadrupled, the original Victorian infrastructure being replaced by a four-platform station with very basic waiting shelters on each side. A lattice girder footbridge provided access to the twin island platforms.

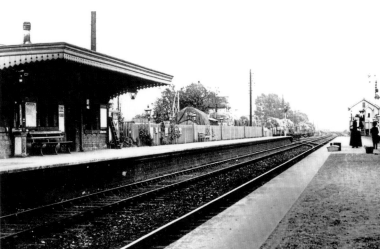

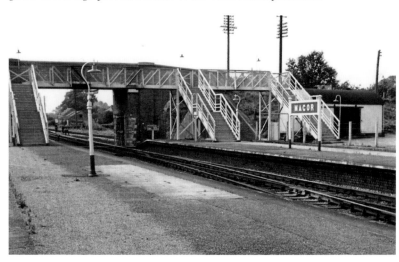

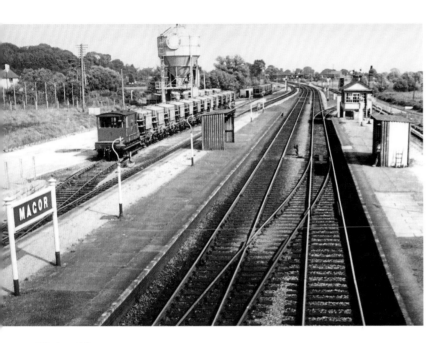

Right: **Magor**

Class 37 locomotive No. 37234 weaves its way across from the Down Relief to the Down Main Line with a rake of empty rake of 'HAA' coal hoppers on 4 September 1986. This locomotive was converted into a Class 37/5 (as No. 37685) a few months after this photograph was taken. The 'period' feel of the picture is enhanced by the vintage motor coaches parked in the former station yard, which dated from 1968 and 1969, and were already regarded as classic vehicles when the photograph was taken.

Left: **Magor**

A further view of Magor station during the early 1960s, showing the track layout after quadrupling of the line. Sadly, Magor became yet another victim of the ruthless purge of local stations that was carried out on 2 November 1964, but there have been repeated suggestions that this wayside stopping place could be reinstated – a local pressure group known as 'the Magor Action Group on Rail' (MAGOR) having been formed in May 2012 to campaign for a new station, which they hope will be conveniently-sited next to a planned community centre in the village.

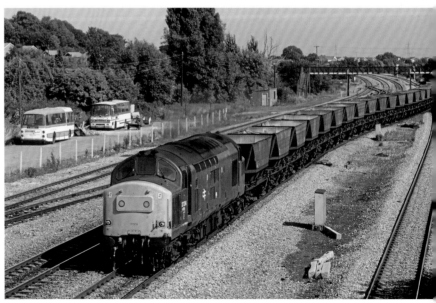

Magor

Left: Class 60 locomotive No. 60094 *Tryfan* passes Magor with the 5.40 a.m. Roberston to Westerleigh Murco oil tanks on 3 September 1999. Unfortunately No. 60094 lost its Welsh mountain name shortly afterwards in favour of the far less memorable *Rugby Flyer*.

Below Left: An HST set headed by power car No. 43168 hurries the 3.00 p.m. Paddington to Swansea First Great Western service past Magor on 14 March 1997.

Below Right: Sporting inappropriate Trainload Construction livery, Class 60 locomotive No. 60016 *Langdale Pikes* passes Magor with the 1.15 p.m. Westerleigh to Roberston oil empties on 14 March 1997.

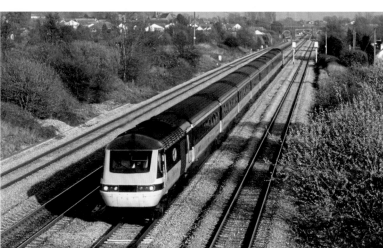

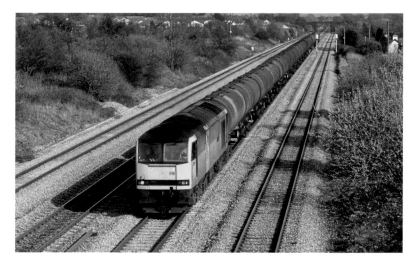

Llanwern

From Magor, the route continues to the now closed station at Llanwern (155 miles). Opened in October 1855, Llanwern station was originally situated in rural surroundings, but this situation was utterly transformed by the construction of the Llanwern steel plant after the Second World War. This vast complex was opened by Richard Thomas & Baldwin Ltd in 1962, and it extends for a considerable distance alongside the main line.

The opening of the steelworks was accompanied by a programme of track improvements and engineering work, in order to accommodate the extra traffic that was expected to flow over the South Wales main line once the plant was in full production. These new works entailed a major re-organisation of the running lines in the vicinity of Newport. The wartime quadrupling scheme had resulted in the up and down relief lines to the east of Newport being placed on each side of the main up and down lines, whereas to the west of Newport the up and down relief lines were sited on the south side of the main lines. This meant that passenger services were frequently delayed by slow-moving goods trains between Newport and Magor, and to eradicate this problem the four tracks between Newport and Magor were rearranged, with the goods lines to the south. A new fly-over at Bishton enabled freight trains to pass over the main lines in order to rejoin the up relief line – which remained on the north side from this point in order to permit non-conflicting access to the up side marshalling sidings at Severn Tunnel Junction.

The upper photograph provides a glimpse of Llanwern station during the Edwardian period. Notwithstanding the importance of the new steelworks, Llanwern was closed to passengers with effect from 12 September 1960. The lower view shows Class 37 locomotives Nos 37636 and 37274 near Bishton with the 3.08 p.m. Pathfinder Tours Fishguard Harbour to Coventry Pembrokeshire Pageant railtour on 2 August 1997. Llanwern Steelworks dominates the background, while the up relief line can be seen curving in from the right, having just crossed the main line on the Bishton Flyover.

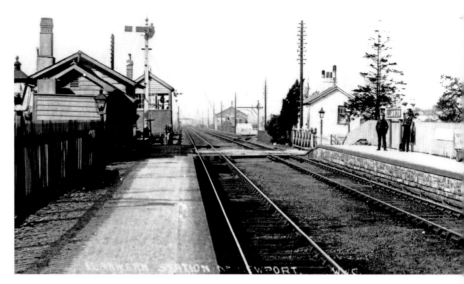

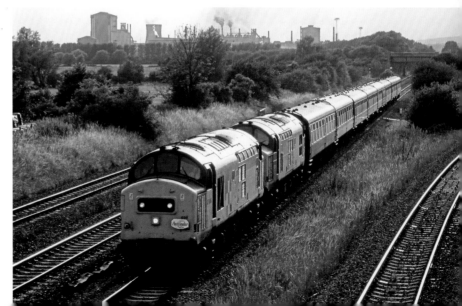

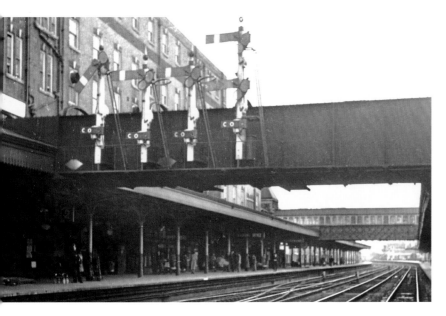

Right: Newport High Street

A further programme of improvements was carried out by the Great Western over a seven year period finishing in 1930. A modern power signal box, with 96 levers was brought onto use on 29 May 1927 when a new Newport East Box replaced Newport East and Maindee West boxes, and in the following year a similar installation with 125 levers was opened at Newport West. Other improvements included platform extensions and the provision of an impressive, five-storey station building on the down side. This new structure was in the neoclassical style, its appearance being described as 'magnificent' by *The Great Western Railway Magazine*. In steam days, the platforms were numbered from 1 to 8, but in its present-day form the station has four through platforms, which are numbered from 1 to 4. The photograph shows the façade of the main station building.

Left: Newport High Street

On approaching the important intermediate station at Newport (158¾ miles), down trains reach Maindee Junction, where the north and west route to Hereford and Shrewsbury leaves the South Wales main line. Beyond, trains cross the River Usk on an impressive bridge consisting of a series of girder spans resting on massive stone piers. Newport station is only a short distance further on.

Known for many years as 'Newport High Street', Newport station was opened by the South Wales Railway on 19 June 1850. The station was enlarged during the 1870s, and in its rebuilt form Newport High Street incorporated lengthy up and down platforms for main line traffic and an additional through platform on the up side – the up platform being an island with tracks on either side. Four tracks were provided between the up and down platforms, and these were equipped with scissors crossovers, so that each platform could accommodate two trains. A bay platform was sited at the west end of the main down platform, and an additional platform was subsequently added for local Valleys traffic on the up side.

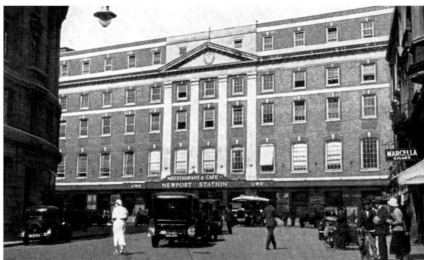

Right: Newport High Street

Class 09 shunting locomotive No. 09015 rests at Ebbw Junction on 24 July 1996 between spells of work in the nearby Alexandra Dock Yard. In common with all of the original build Class 09s, No. 09015 spent its early life at work in the Southern Region, before moving to South Wales in March 1989 – the first Welsh shed to receive them being Cardiff Canton in March 1989. These locomotives were visually-similar to the standard Class 08 0-6-0 shunters, but they had a slightly higher maximum speed of 27½ miles per hour, which enabled them to be used for hauling short-distance local freight workings in addition to their normal shunting duties.

Left: Newport Ebbw Junction

Shed Newport was the site of Ebbw Junction shed – an important motive power depot, and the largest GWR shed in South Wales. This major facility was sited to the west of the passenger station, the shed building being a large 'roundhouse' structure containing two turntables. There were, in addition, a number of other facilities including offices, stores, workshops and a coaling plant. The main shed was a substantial, brick-built structure measuring approximately 363 feet by 245 feet at ground level, while the adjacent repair shop measured 197 feet by 112 feet. In later years, the usual allocation was around 145 locomotives, including large 4-6-0s for main line services, and various 2-8-0, 2-6-0, 2-6-2T and 0-6-0 classes for goods services and local passenger work. The photograph shows the interior of one of the sheds, circa 1962, with 57XX Class 0-6-0PTs Nos 4627, 4643 and 8705 clustered around one of the turntables.

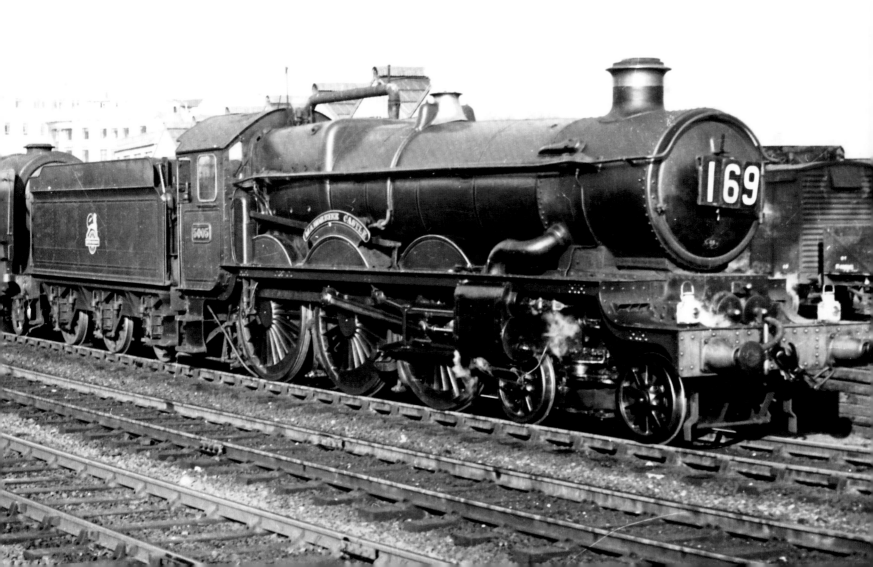

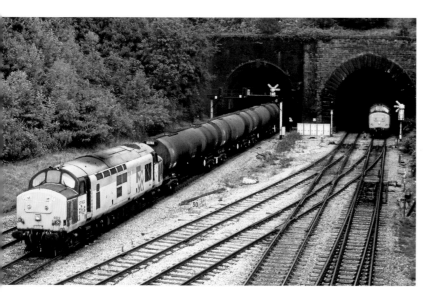

Right: **Newport Ebbw Junction**

HST Power car No. 43181 *Devonport Royal Dockyard 1693–1993* leads the 2.00 p.m. Paddington to Swansea service past Ebbw Junction on 24 July 1996. Alexandra Dock Junction Yard can be seen in the background, while the area of wasteland visible to the left marks the of Ebbw Junction shed, which was closed in October 1965. Class 09 shunting locomotive No. 09015 can be seen pottering around in the distance.

Opposite: **Newport High Street**

Castle Class 4-6-0 No. 5005 *Manorbier Castle* pilots an unidentified Britannia Class 4-6-2 at Newport during the 1950s. The Castles were introduced in 1923, and they soon appeared in South Wales, twelve of these engines being allocated to Cardiff Canton shed by 1938, while a further eleven were stationed at Landore. They were, at first, employed mainly on Paddington services, but they also appeared on the north and west route, hauling the principal express services between Cardiff and Shrewsbury.

Left: **Newport Hillfield Tunnel**

Trains approaching Newport High Street from the west pass through the 180-yard Hillfield Tunnel. The photograph, taken on 11 September 1997, shows Class 37 locomotive No. 37902 emerging from the western portal of the tunnel at the head of the 10.05 a.m. Llanwern to Cardiff Tidal oil empties, while sister locomotives Nos 37670 and 37696 wait at the signal to gain entry to the nearby Alexandra Dock Yard with the 4.56 a.m. Enterprise freight service from St Blazey. The tunnel was doubled in 1912, when the Great Western constructed a new double-track tunnel beside the original bore.

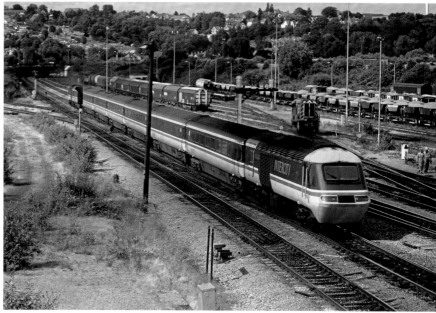

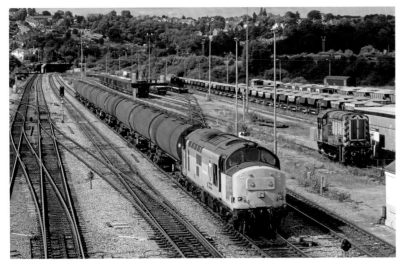

Newport – Ebbw Junction

Left: Running over an hour early, Class 37 locomotive No. 37897 passes Ebbw Junction with 3.07 a.m. Didcot Power Station to Cardiff Tidal oil empties on 24 July 1996; this service was a 'Wednesdays Only', as required working. Class 09 shunter No. 09015 can be seen to the right.

Below Left: HST power car No. 43009 leads the 1.00 p.m. Paddington to Swansea service past Ebbw Junction on 15 February 2003.

Below Right: Running exactly on time, Class 60 locomotive No. 60097 *ABP Port of Immingham & Grimsby* passes Ebbw Junction with the 5.08 a.m. Lackenby to Margam steel slab train on 15 February 2003. Class 66 locomotives Nos 66135 and 66241 can be glimpsed in the background.

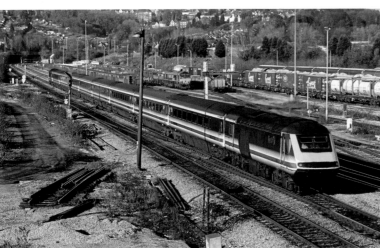

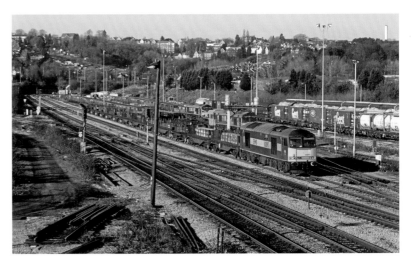

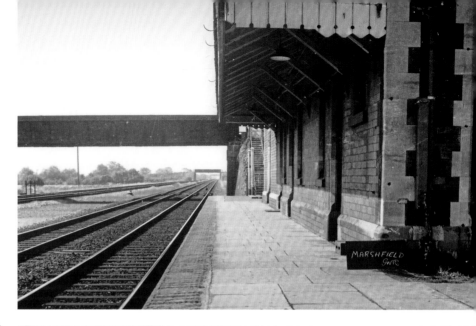

Marshfield

On leaving Newport, down workings head south-west towards Cardiff passing, en route, the closed station at Marshfield (164 miles), which was opened on 2 September 1850 and deleted from the railway system with effect from 10 August 1959. The 1938 Railway Clearing House *Handbook of Stations* reveals that Marshfield was able to deal with coal, livestock, horse boxes and general merchandise traffic. The accompanying photographs were taken after closure, but they show the former station building in some detail. This brick-built structure was of typical Great Western design, suggesting that the GWR had replaced the original South Wales station building during the late Victorian period.

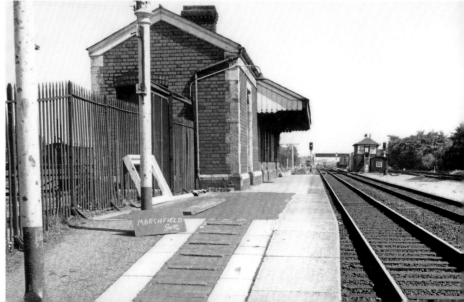

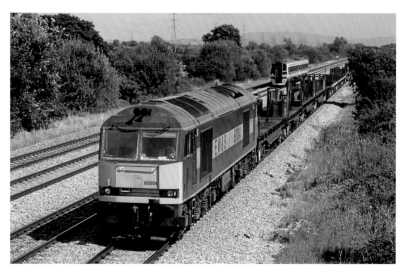

Marshfield

Left: 'The race is on' at Marshfield on 27 August 1998 as Class 60 locomotive No. 60004 heads westwards along the multiple-tracked main line with the 9.02 a.m. Dee Marsh to Margam steel empties, while Class 158 unit No. 158843 is about to overtake it with the 9.24 a.m. Portsmouth Harbour to Cardiff Central service.

Below Left: An HST set headed by power car No. 43152 hurries eastwards with the 9.30 a.m. Swansea to Paddington First Great Western service on 4 March 2006, while Class 37 No. 37411, which cannot hope to catch up, works the 10.25 a.m. Cardiff Central to Newport special, run in connection with the Powergen Cup Rugby Semi-Finals.

Below Right: Class 60 locomotive No. 60065 *Kinder Low* heads westwards through Marshfield with an empty Llanwern to Port Talbot iron ore working on 24 July 1996. The empty ore train is about to be overtaken by Class 158 unit No. 158826, forming the 9.00 a.m. Brighton to Tenby Regional Railways service.

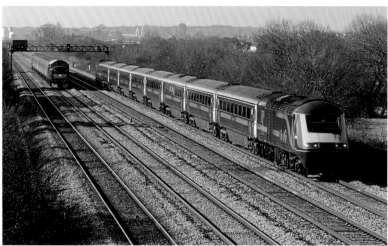

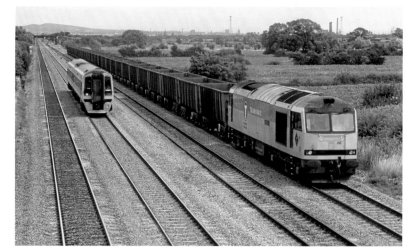

Cardiff General

Heading south-west towards Cardiff, the capital city of Wales, trains pass the site of an abandoned suburban station at Roath, which had a very short life, having been opened on 2 June 1899 and closed as a wartime economy measure in April 1917. The main line station at Cardiff (170½ miles), known for many years as 'Cardiff General', was opened by the South Wales Railway on 19 June 1850. It was rebuilt in 1876 when two through lines were inserted between the up and down platform lines – the elimination of the broad gauge having created sufficient space for these additional lines. Taff Vale and Barry Railway services from Barry and Penarth used two additional platforms on the south side, which were deemed to be a separate station known as 'Cardiff Riverside' until October 1940, when they were amalgamated with the main line station as Platforms 8 and 9.

As mentioned in the historical section, the GWR absorbed a number of formerly independent Welsh railways at the time of the Grouping, and it was, in consequence, decided that Cardiff station would be rebuilt to permit better integration of services on these formerly independent lines. The work, completed in 1934, included the provision of striking new art deco style station buildings and altered platform arrangements, together with the installation of colour light signalling and two new signal boxes containing power-operated frames and electric interlocking. In August 1933 *The Railway Magazine* reported that one of the new boxes contained 339 levers, thereby making it, at that time, 'the largest power-operated frame' in the country.

The upper picture shows the west end of Cardiff GWR station around 1912, looking towards Paddington with Platform 3 in the centre of the picture and Platform 1 on the extreme left. The lower view is looking eastwards along Platform 1 during the early 1900s.

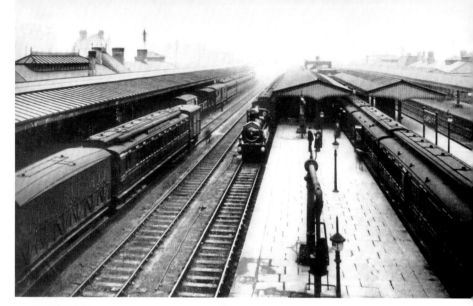

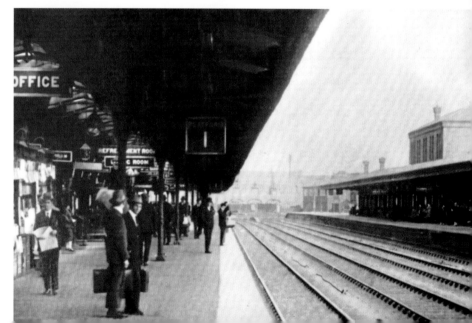

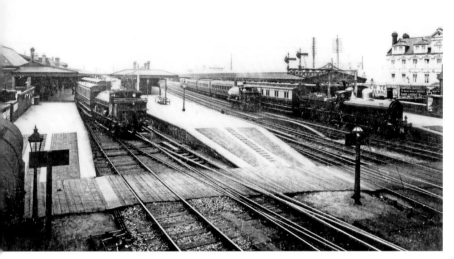

Left: Cardiff General
A general view of Cardiff station around 1912, looking west towards Fishguard. At the present time the station has seven platforms that are oddly numbered from 0 to 7. Platforms 3 and 4 are sub-divided into 'a' and 'b' sections, and there is no Platform 5, this being the number of a former bay platform. In steam days the railway infrastructure at Cardiff was very extensive; there were, for example, two important motive power depots at Cardiff Dock and Cardiff Canton – Canton shed being sited to the west of the passenger station on the down side. Coded '86C' during the BR era (later '88A') this very large shed had an allocation of over 100 locomotives, including Saint, Castle, Hall and Grange Class 4-6-0s; 28XX 2-8-0s, 43XX 2-6-0s; 42XX 2-8-0Ts; Dean Goods 0-6-0s and 57XX Class 0-6-0PTs. Cardiff Canton was closed to steam in 1962, but the depot remains in operation as a traction maintenance depot.

Right: Cardiff General
This circa 1961 view is looking east towards Paddington from the present Platform 4a. Platforms 6 and 7 can be seen to the right, while the sharply-curved platforms that can be glimpsed on the extreme right are the former 'Cardiff Riverside' platforms, which subsequently became Platforms 8 and 9; they were used as parcel bays after 1965, and closed in 1992. Cardiff has, in recent years, generated over 13 million passenger journeys each year and, as such, it is said to be the eleventh busiest station in the United Kingdom outside of London. It has been suggested that this busy station could be reconstructed as part of an ambitious regeneration scheme, although nothing had been decided at the time of writing.

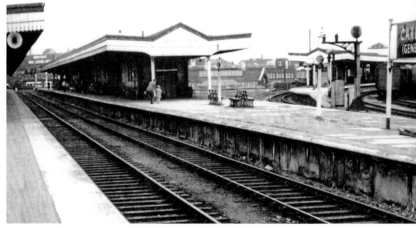

Right: **Ely Main Line**

From Cardiff, the railway turns inland, away from the coast, as it heads first west, and then north-west towards Bridgend and Swansea. The abandoned station known as Ely Main Line (172¾ miles) was opened by the South Wales Railway on 2 September 1850, and closed with effect from 10 September 1962. It was situated on the western edge of the Cardiff urban area and, for this reason, it developed as a suburban station, around 400,000 tickets per annum being issued during the early years of the twentieth century. The station also handled significant amounts of goods traffic, much of which emanated from the rail-linked Ely Paper Mills, or from the neighbouring Cresswell's Brewery, which can be seen behind the station in this circa-1960 view.

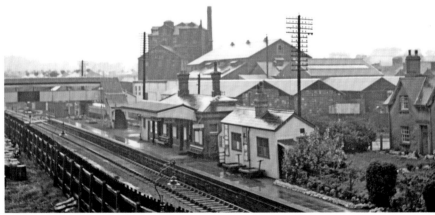

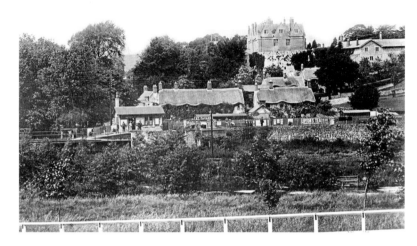

ST. FAGANS. No. 425

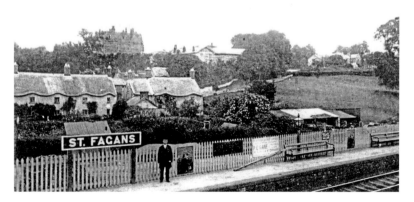

ST. FAGANS

St Fagans

Left: Heading westwards, trains pass St Fagans (174½ miles), the site of a small station that remained in use from 1 April 1852 until 10 September 1962. This Edwardian postcard view shows the station and village, the diminutive station building being visible to the left of the picture.

Below Left: A further view of the station during the Edwardian period. In operational terms, St Fagans had some importance, insofar as it was an interchange point with the Barry Railway – a number of exchange sidings being available on the up side.

Below Right: Class 37 locomotive No. 37425 passes the church at St George's (sometimes known as St George's-super-Ely), to the west of St Fagans, on a dreary 14 August 2004 while hauling the 9.11 a.m. Rhymney to Fishguard Wales & Borders service. The 700-year-old church (naturally dedicated to St George) is a little distant from the main part of the village.

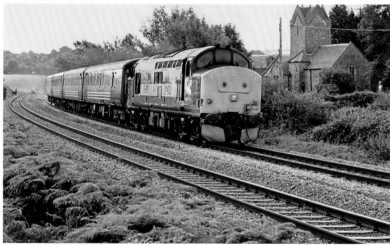

Llantrisant

Continuing due west beyond St Fagans, the South Wales route passes beneath the now closed Barry Railway main line, and trains then run through the site of Peterston station (177½ miles), which was opened in 1858 closed with effect from 2 November 1964. Beyond, the route follows the Ely Valley to Llantrisant (181½ miles). This once busy station was opened with the line on 19 June 1850, and it became the junction for branch services on the Taff Vale route to Cowbridge on 18 September 1865. The Cowbridge line was extended southwards to Aberthaw on 1 October 1892, after which Taff Vale services were able to run through from Pontypridd to Aberthaw, with a reversal at Llantrisant station.

Llantrisant was also the junction for the Ely Valley Railway, which was authorised on 13 July 1857 with powers from the construction of a broad gauge branch to Penygraig, in the Rhondda Valley, with branches to Gellyrhaidd and Castella. In addition, the Ely Valley system incorporated a mineral branch to Brofiscin and connections with the Llynfi & Ogmore line at Gellyrhaidd Junction, and the Taff Vale branch from Pontypridd at Llantrisant Common Junction and Maesaraul Junction. Although the Ely Valley Railway was primarily a mineral line, passenger services were introduced between Llantrisant and Penygraig on 1 May 1901. The Ely Valley Railway was amalgamated with the GWR in 1903.

The upper picture shows Llantrisant station around 1912, looking east towards Paddington, while the lower view is looking westwards in the opposite direction. In its heyday in the early years of the twentieth century Llantrisant station issued over 200,000 tickets per annum, while freight traffic amounted to about 50,000 tons per year.

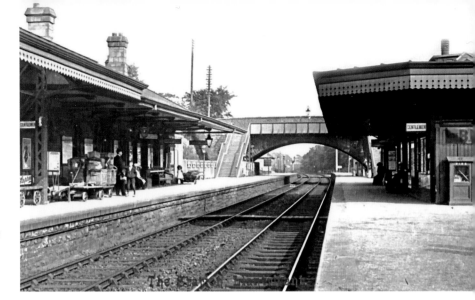

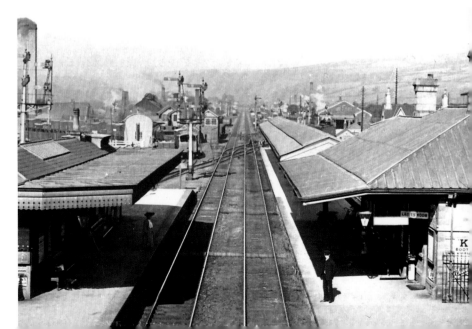

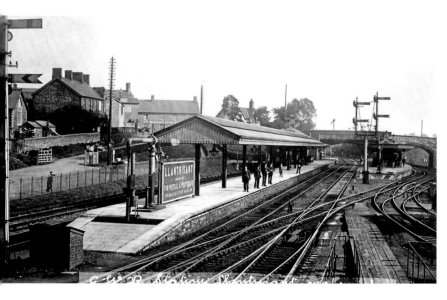

Left: Llantrisant
A further view of Llantrisant station during the early 1900s, looking east towards Paddington with the up platform visible in the centre of the picture. The Cowbridge branch platform is on the extreme right, while the Ely Valley branch bay can be seen to the left. Penygraig branch services were normally worked by small tank engines, Metro 2-4-0Ts being used for many years, although Collett 14XX Class 0-4-2Ts became the usual form of motive power during the BR period. In 1947, at the end of the GWR era, Llantrisant was served by around thirty daily main line services, together with about a dozen daily passenger workings on the Penygraig, Cowbridge and Pontypridd lines. The infrastructure here included a busy goods yard and a 3-road engine shed, the latter having an allocation of about sixteen locomotives, roughly half of these being Collett 57XX Class 0-6-0PTs.

Right: Llantrisant
A later view of Llantrisant station, taken from a similar vantage point around sixty years later, with the Penygraig bay to the left and the Cowbridge branch platform to the right of the picture. The Cowbridge and Pontypridd branches were closed with effect from 26 November 1951 and 31 March 1952 respectively, while passenger services were withdrawn from the former Taff Vale route between Llantrisant and Penygraig with effect from 9 June 1958, the last trains being run on Saturday 7 June.

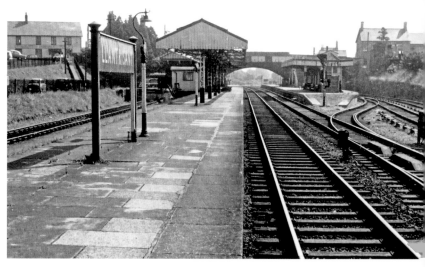

Llantrisant and Pontyclun

Right: A glimpse of the down platform at Llantrisant, possibly around 1920.

Below Right: The up and down platforms extended beyond the road bridge, as shown in this circa 1964 photograph.

Below Left: This final view of Llantrisant station is looking west towards Fishguard around 1964. The station was closed with effect from 2 November 1964, although goods traffic lingered on until 1983. Passenger services were restored just under nine years later, on 28 September 1992, the present unstaffed station, built on the site of the original platforms, being known as Pontyclun.

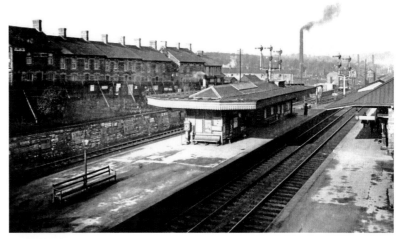

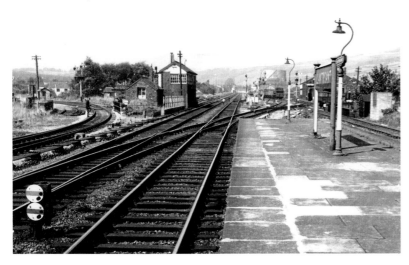

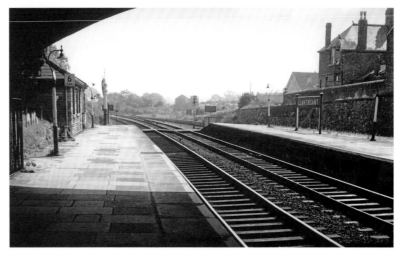

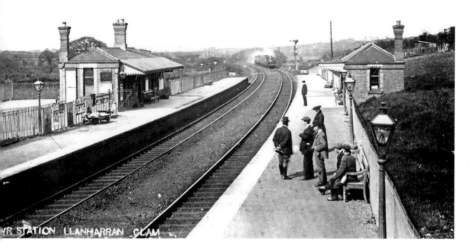

Llanharan

Climbing at 1 in 106, the route heads north-westwards to Llanharan (184 miles). This small station was a relatively late addition to the local railway system, having been opened by the GWR on 1 September 1899. It was the junction for the Cardiff & Ogmore Valley Railway, which joined the main line at the east end of the platforms, and formed a link with the Llynfi & Ogmore system at Tondu. This mineral line had been opened in 2 October 1876, and it formed part of a direct route between Cardiff and the Llynfi, Ogmore and Garw valleys.

The upper photograph, dating from the early years of the twentieth century, is looking west towards Fishguard, the main station building, of standard Great Western design, being on the down platform, while the up platform is equipped with a subsidiary waiting room. In 1903, this small station issued 25,546 ordinary tickets, rising to 39,528 tickets in 1913, and 55,528 ordinary tickets and 292 seasons by 1923. The lower view is looking east towards Paddington during the British Railways period around 1964. Llanharan West Signal Box can be seen in the distance; this 42-lever cabin was closed in 1966. The Cardiff & Ogmore Valley line formerly trailed-in from the left, joining the main line between the signal cabin and the end of the up platform.

The original Llanharan station was closed with effect from 2 November 1964. But this was not the end of the story and, following a local campaign, a new station was opened in December 2007. The resurrected stopping place is an unstaffed halt with simple waiting shelters and a small car park. The up and down platforms are linked by a footbridge with gently-sloping approach ramps for the benefit of wheelchair users.

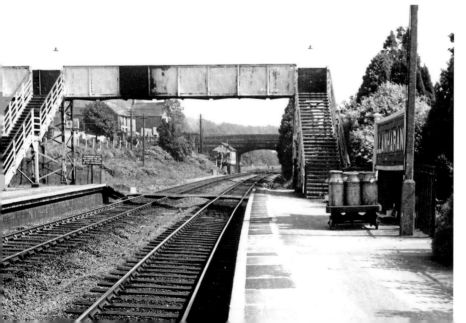

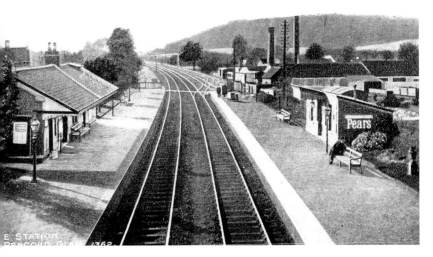

Right: **Pencoed**
A further view of Pencoed station, looking north-east towards Paddington, with the main station building to the right of the picture. Pencoed East Signal Box, visible beyond the footbridge, survived as a gate cabin until 2007. The later history of Pencoed station echoes that of Llanharan in that, having succumbed to closure with effect from 2 November 1964, a new station was brought into use on 11 May 1992. In its present-day form, Pencoed station has staggered platforms, the up platform being sited somewhat further to the east than its counterpart on the down side – the two platforms are, moreover, separated by the Hendre Road Level Crossing, which has been equipped with lifting barriers since 1976.

Left: **Pencoed**
Pencoed, the next station (186¾ miles) is a little under 3 miles further on. Opened by the South Wales Railway on 2 September 1850, the station was laid out on an approximate north-east to south-west alignment, with its main station building on the down platform and a small waiting shelter on the opposite side. The up and down platforms were linked by a lattice girder footbridge, and Hendre Road crossed the line on the level at the east end of the station. The goods yard, sited to the west of the platforms on the up side, contained sidings for coal and other forms of goods traffic, while in earlier years a tramway had provided a link to a nearby brickworks.

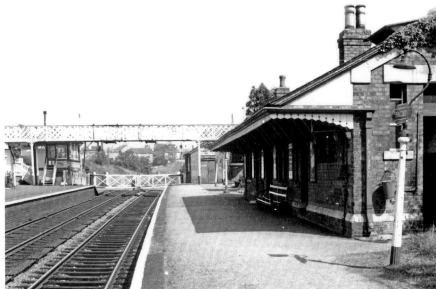

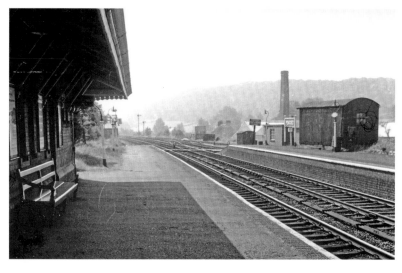

Pencoed

Left: A final view of the old station, looking south-west towards Fishguard during the 1960s.

Below Left: Class 56 locomotive No. 56087 passes Pencoed with the 11.05 a.m. Llanwern to Port Talbot MGR empties on 4 April 1992.

Below Right: Class 60 locomotive No. 60093 *Jack Stirk* passes Pencoed with the 10.27 a.m. Margam to Lackenby steel empties on 15 July 2002.

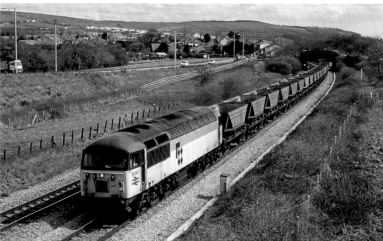

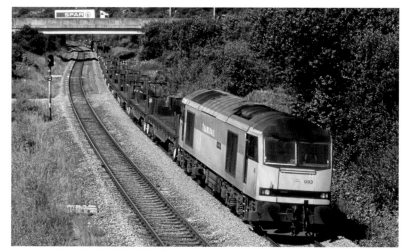

Bridgend

Now heading south-westwards, trains approach Bridgend (190½ miles) passing, en route, the site of a non-timetabled stopping place known as Tremains Factory Platform, which served a Royal Ordnance factory and was in use from 1939 until the 1960s. Bridgend station was ceremonially opened with the line on 18 June 1850, and it soon developed as a major traffic centre, being the junction for traffic from the Llynfi & Ogmore Railway as well as the Vale of Glamorgan Railway. The Llynfi & Ogmore Railway was amalgamated with the GWR in 1883, but the Vale of Glamorgan route was worked by the Barry Railway until it was absorbed by the GWR in 1922.

Bridgend station is laid out on an approximate south-east to north-west alignment, with its main station building on the down side. The up and down platforms are linked by a plate girder footbridge, and the still-extant station building incorporates a typical Brunelian 'chalet' type building that dates back to the opening of the line in 1850. The station has four platforms, the down platform having a south-facing bay for Vale of Glamorgan services, while the up platform was formerly an island with tracks on either side. However the outer face, which is used by Llyn & Ogmore services has now been converted into a terminal bay. The Llynfi & Ogmore route to Tondu diverges northwards about half-a-mile beyond the station, while the Vale of Glamorgan line leaves the main line at the south-eastern end of the station.

The upper photograph shows Bridgend station, possibly around 1920, looking north-westwards from an elevated position, while the lower view, dating from about 1910, is looking along the down platform; Barry Railway 2-4-2T locomotive No. 87 is in the down bay, while GWR 4-4-0 locomotive No. 3422 *Sir John Llewelyn* stands alongside the up platform.

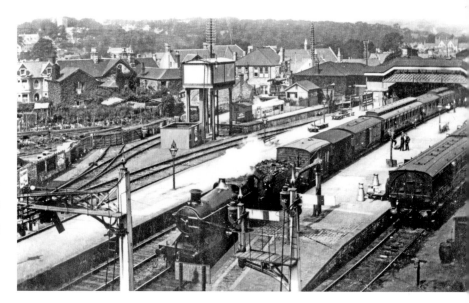

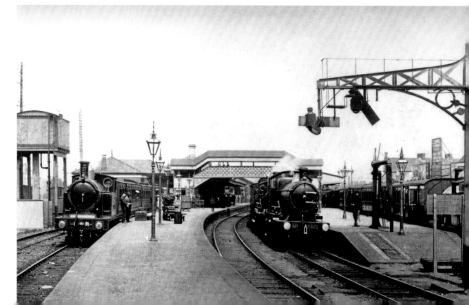

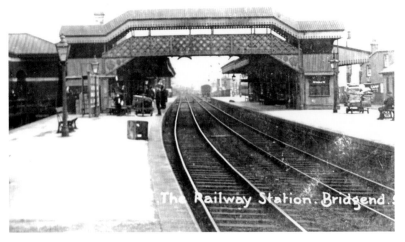

Bridgend

Left: An old postcard view of Bridgend station looking north-west towards Fishguard with the main station building to the left.

Below Left: A detailed view of the lattice girder footbridge during the early 1960s. The platforms were, at that time, numbered from 1 to 4, but the main line platforms are now Platforms 1 and 2, while the up and down bays have been designated Platform 3 and Platform 1A respectively.

Below Right: The north-western end of the platforms, with the goods shed just visible on the extreme left. The station was reconstructed in 1979 – the listed Victorian building on the down side being renovated, while a new circulating area and travel centre was built alongside the original 'Brunelian' building. At the same time, the old buildings on the up side were replaced by an entirely new structure containing a buffet bar and waiting room.

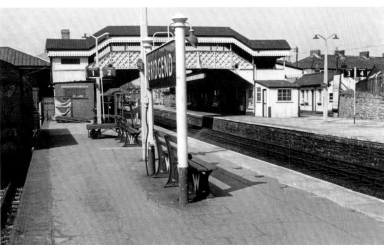

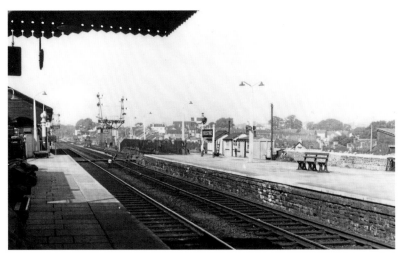

Bridgend

Right: Class 37 locomotives Nos 37886 and 37707 pass the ruined farm buildings at Llangewydd, to the west of Bridgend, with the 7.04 a.m. Pathfinder Tours Crewe to Ebbw Vale Onllwyn Orbiter rail tour on 2 June 2001; Class 60 locomotive No. 60026 is out-of-sight at the rear of the train.

Below Left: Class 56 locomotive No. 56108 passes Llangewydd with the Llanwern to Port Talbot coal empties on 15 April 1991. By this date 'sectorisation' of the BR system had taken firm hold, and many locomotives were appearing in the new triple grey freight sector liveries. There was, nevertheless, still plenty of variety, and many locomotives still carried their original Railfreight, and later 'Red Stripe' Railfreight livery. Note the milepost on the left indicating 193¼ miles from Paddington via Swindon and Gloucester – the original milepost distances on the South Wales line having remained unaltered after the opening of the Severn Tunnel route.

Below Right: Class '37' locomotive No. 37402 passes Llangewydd with the 1.35 p.m. service from Fishguard to Rhymney on 20 September 2002.

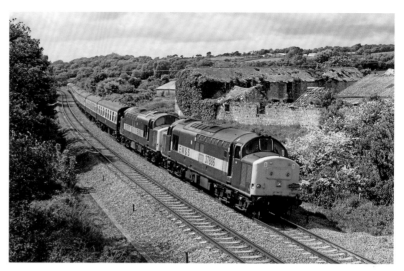

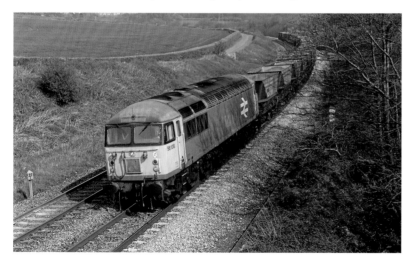

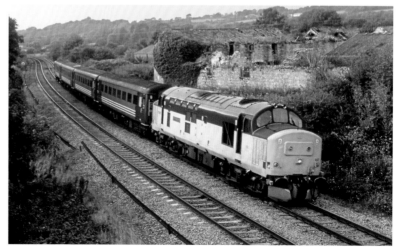

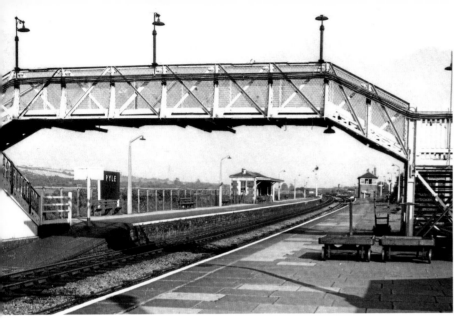

Pyle

On departing from Bridgend, down workings run first north-westwards and then westwards to Pyle (196¾ miles), the next stopping place. This station has a somewhat contorted history, having been opened by the South Wales Railway on 19 June 1850, and rebuilt on a new site on 13 November 1876 in order to provide better inter-change facilities with the Tondu to Porthcawl branch of the Llynvi & Ogmore line. When opened for passenger traffic on 1 August 1865, the Porthcawl branch had crossed the main line on the level, but this inconvenient 'flat' crossing was replaced by a bridge when the new station was brought into use. The upper picture shows the main line platforms around 1964, while the lower view shows the slightly-curved Porthcawl platforms; the Llynvi & Ogmore Railway was absorbed by the GWR in 1874.

Although the Porthcawl branch carried significant numbers of passengers during the holiday season, the line was closed with effect from 9 September 1963, while Pyle station was deleted from the BR system with effect from 2 November 1964. However, in the 1990s it was decided that local services between Bridgend and Swansea would be revived as part of the 'Swanline' project, funding of £5.6 million having been guaranteed by BR, the Welsh Office, the European Regional Development Fund and various local authorities. The scheme involved the reopening of five intermediate stations, one of these being Pyle, which was reopened for public traffic on 27 June 1994 – although the 'official' reopening did not take place until 11 July. In its present-day guise, the station is an unstaffed stopping places with open-fronted waiting shelters on each side.

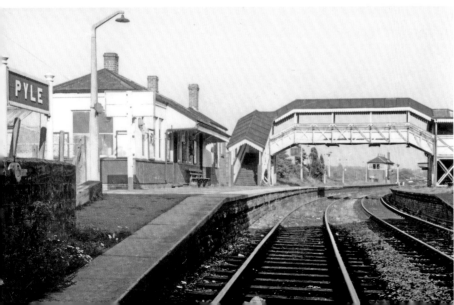

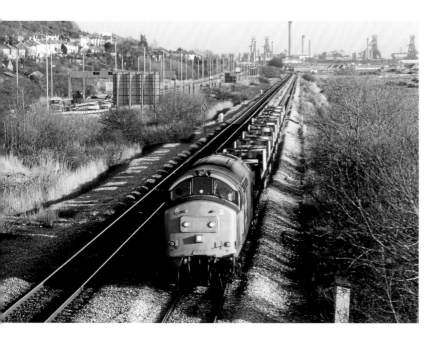

Right: **Briton Ferry**
Running northwards through a heavily-industrialised area, trains reach Briton Ferry (206 miles), which was formerly served by two stations – the South Wales Railway station having been opened on 2 September 1850, whereas the neighbouring Rhondda & Swansea Bay station was brought into use on 14 March 1895. These two stations were designated 'Briton Ferry West' and 'Briton Ferry East' respectively following the Grouping, while on 16 September 1935 both stations were replaced by a spacious new four-platform station that was sited about 600 yards further east than its predecessors. The second station was closed with effect from 2 November 1964, having become a victim of the Beeching cuts, but a new station was opened on 1 June 1994 as part of the 'Swanline' project. This resurrected stopping place has slightly-staggered platforms and open-fronted shelters, and it is now attracting over 20,000 passengers per annum.

Left: **Baglan**
From Pyle the route heads north-westwards through an industrial area that is still dominated by the steel industry. A non-timetabled workmen's halt at Margam was used by steel workers from 1948 until 1964, but Port Talbot (202¾ miles), the next station, remains in operation as part of the national railway system. Here, in pre-Grouping days, connections were made with the Port Talbot Railway and the Rhondda & Swansea Bay Railway – both of these lines being managed by the GWR from 1906. Beyond, the line continues to Baglan, a relatively new stopping place that was brought into use on 2 June 1996. The photograph shows Class 37 locomotive No. 37902 passing the site of Baglan station at the head of the 4.05 p.m. Margam to Trostre steel coil train on 25 March 1987.

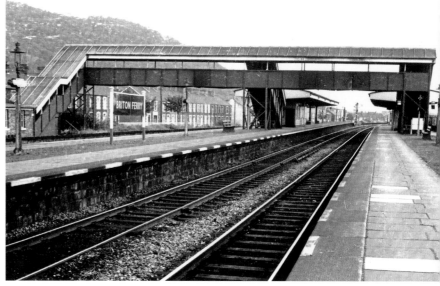

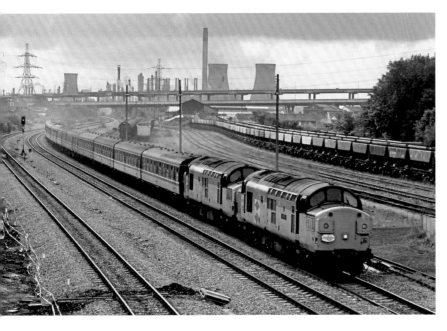

Right: Briton Ferry

A seven-coach HST set, headed by power car No. 43171, is pictured approaching Briton Ferry with the 3.35 p.m. Swansea to Paddington service on 25 March 1987. The train consists of an almost-complete rake of vehicles in the original HST livery, except for the rear power car. Great Western HST sets are now being repainted in an overall dark green colour scheme that has presumably been inspired by the traditional GWR locomotive livery. The majority of today's HST sets are eight-car formations, but at least one nine-car formation has been recorded on the Great Western main line. The present-day Briton Ferry station is situated on the eastern side of the bridge from which this photograph was taken.

Left: Briton Ferry

Class 37 locomotives No. 37068 *Grainflow* and 37108 pass Briton Ferry with the 5.20 p.m. Pathfinder Tours Preston to Cwmgwrach Neath Navigator rail tour on 2 October 1993. The train is passing sidings full of stored wagons, including well over a hundred redundant HBA domestic coal hoppers. In the foreground, to the left, initial preparation work is taking place prior to the construction of the new Briton Ferry 'Swanline' station, which was opened in the following summer as mentioned on the previous page.

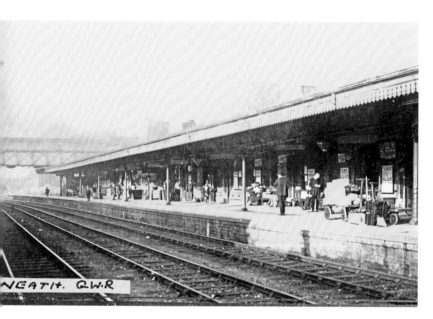

NEATH. G.W.R

Left: Neath General

Heading east-north-eastwards, down trains soon arrive at Neath (208¾ miles), which was opened by the South Wales Railway on 19 June 1850. In steam days, the infrastructure at this busy station had incorporated lengthy platforms for up and down traffic, with extensive buildings on each side. The platforms were linked by a roofed footbridge, and a goods yard was provided on the down side. These facilities dated from the 1870s, when the Great Western carried out a major reconstruction scheme. On 18 August 1877 The *Western Daily News* reported that the 'beautiful new station, elegant in design and light, and yet strong in construction' would be brought into use 'in a few days'. Other new works carried out at that time included the construction of new goods-handling facilities and the provision of a motive power depot. The photograph shows the up platform, probably around 1920; the up and down platform roads were separated by a 'third line' or siding.

The South Wales station was used by the Vale of Neath Railway between 1851 and 1863, and from 1873 until 1880, when Vale of Neath services returned to the neighbouring Neath (Riverside), which was also used by Neath & Brecon services. Neath (Riverside) was also known as Neath Low Level.

Right: Neath General

A detailed view of the main station building at Neath General, which was another standard Great Western structure, dating from 1877. In April 1975 BR started to demolish these substantial stone buildings as part of a £220,000 redevelopment scheme but, following protests from the Victorian Society and other interested parties the work of destruction was halted by a preservation order that became effective on 11 April – although the demolition did not stop until six days later. In the event it was eventually decided that the demolition would continue, and in 1976 Neath Borough Council gave BR permission to proceed with the controversial rebuilding scheme. As a result, the present-day Neath station dates mainly from the mid-1970s, although it is interesting to note that fragments of the original stonework can still be seen.

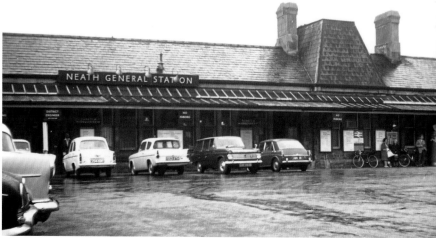

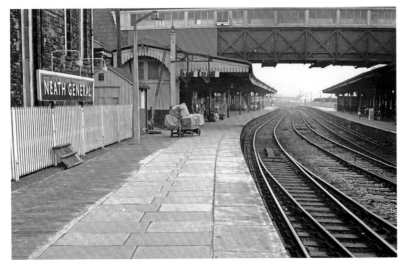

Neath General

Left: A view of the up platform, looking south towards Paddington during the early 1960s.

Below Left: The north end of the up platform, looking towards Fishguard during the 1960s. The large stone building on the extreme right was a non-conformist chapel, while the hip-roofed signal cabin that can be seen in the distance is Neath West Box, which was opened in 1929 and closed in 1967.

Below Right: The south end of the platforms, looking towards Fishguard during the 1960s. The goods shed can be seen to the left of the picture; goods facilities were withdrawn from Neath General in 1981.

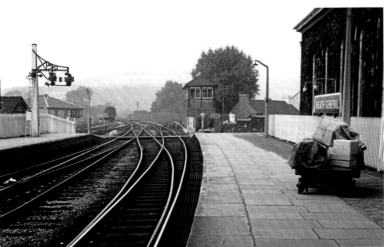

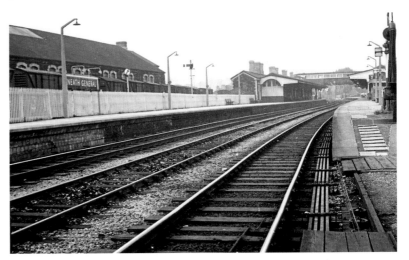

Left: Neath General

On leaving Neath, the line commences a sharp left-hand curve that takes it through a full 180 degree turn as it crosses from one side of the valley to another. The photographs shows an HST set headed by power car No. 43159 accelerating away from Neath with the 3.00 p.m. Paddington to Swansea InterCity service on 28 July 1991. It is crossing the River Neath (Afon Nedd) and will shortly be crossing both the A465 road (seen in the foreground) and the freight-only line to Onllwyn.

Right: **Neath – Some Tickets**

An assemblage of BR and GWR tickets from the central section of the South Wales route, including platform tickets from Swansea, Neath and Llanelly, and four standard Great Western Edmondsons. In Victorian days most railway companies had issued a wide range of tickets in a bewildering variety of colours, but by the 1930s the main line companies had adopted a much-simplified system with standardised colours for different types of tickets. First-class tickets, for example, were white, while third-class issues were green and excursion tickets were generally printed on buff cards. This same basic system continued into the British Railways era.

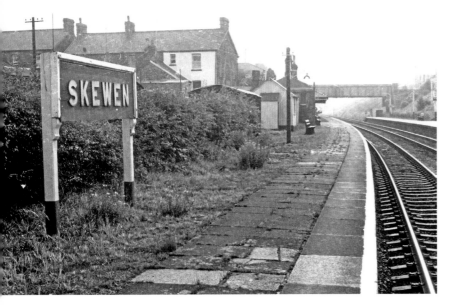

Right: Llansamlett

Heading westwards, trains reach Llansamlett (212½ miles), one of several local stations between Neath and Swansea which were closed with effect from 2 November 1960 and subsequently reopened – suggesting that the so-called 'Beeching Axe' had been swung too widely. This station was opened on 1 April 1852 and rebuilt on a new site about a mile further west on 1 January 1885. The station was sited on an embankment, with a low-level booking office on the down side; it was renamed 'Llansamlett North' in 1950 to distinguish it from the former Midland station on the nearby Swansea Vale route (now closed). The present station, opened on 27 June 1994, is sited in a cutting between the sites of the two earlier stations, and it features staggered up and down platforms with open-fronted shelters on both sides.

Left: Skewen

When opened in June 1882, this wayside station had been known as 'Dynevor', but its name was changed to 'Skewen' in 1904. The station was re-sited 26 chains further east on 1 May 1909, and closed with effect from 2 November 1964. Happily, this was not the end of the story, and on 27 June 1994 Skewen was reopened as part of the 'Swanline' project, the present station being sited a short distance to the west of the 1909 station. The photograph shows the 1909 station looking west towards Fishguard during the 1960s; the main station building is visible to the left, while Station Road is carried across the line in the distance. The present-day station is situated on the west side of the Station Road bridge.

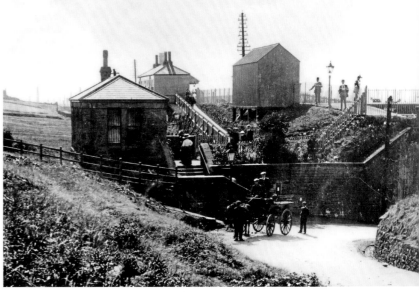

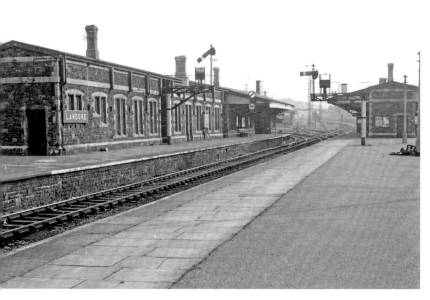

Left: Landore

When opened on 19 June 1850 Landore (214¾ miles), the junction station for Swansea, was regarded merely as a 'ticket platform', although passengers were booked from an early date. The station was rebuilt on a new site towards the end of the Victorian period, and a triangular junction was subsequently constructed to the west of the station. Through coaches for Swansea High Street were attached and detached here for many years. However, since 1926 most West Wales services have run into and out of Swansea, making use of the triangular junction at Landore. The station was closed with effect from 2 November 1964, but Landore remained of operational importance, insofar as it was the site of a large motive power depot, which was coded '87E' during the BR era. In 1921, Landore had an allocation of sixty-six locomotives, comprising twenty-seven Castle, Star and Grange Class 4-6-0s, three small tender locomotives and forty-three tank engines.

Right: Swansea High Street

Now proceeding southwards, trains continue for a further two miles into Swansea High Street station (216¼ miles) which, despite its obvious importance as a traffic centre, has always been a terminal station sited at the end of a short branch from Landore. The original station, ceremonially opened on 18 June 1850, had featured a cavernous overall roof, but the present day station is of more recent construction, the platforms and some of its buildings having been constructed as part of a major rebuilding programme carried out in the 1880s, whereas the three-storey terminal building shown in the photograph was added during the 1920s as part of an ambitious £10 million new works programme that was put into effect by the GWR after the Grouping.

Right: Swansea High Street

A platform-end view, looking north towards Landore during the mid-1960s, the hip-roofed signal cabin, which can be seen in the distance, was closed in October 1973. An array of carriage sidings were located to the north of the passenger station, together with a large goods yard, which was one of several goods-handling facilities in the immediate vicinity – each of the different main line companies that served Swansea having their own goods yards, while further yards were available within the extensive Swansea docks complex.

Left: Swansea High Street

A general view of the platforms around 1963, looking south towards the terminal buffer stops. There were, for many years, five platforms for passenger traffic, but Platform 1, on the right of the picture, was removed in 1973, and the four remaining platforms were then renumbered from 1 to 4. The station was bypassed, on its eastern side, by a connecting line that gave access to Swansea North Dock and the Swansea Harbour Trust lines, and terminated by an end-on junction with the Swansea & Mumbles Railway. The station was known as Swansea High Street to distinguish it from various other stations in the area – the most important of these being Swansea St Thomas and Swansea Victoria stations, which were used by the Midland and London & North Western railways respectively. A further station, later known as 'Riverside', was used by the Rhondda & Swansea Bay Railway.

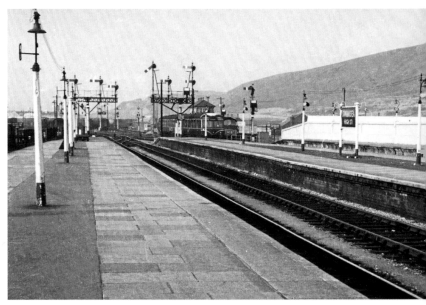

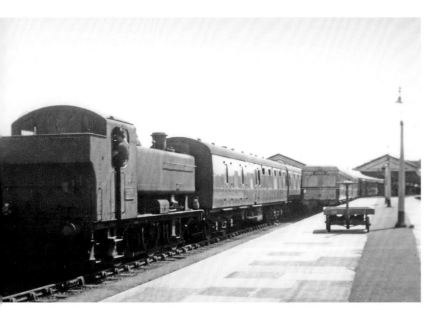

Left: Swansea High Street

An unidentified 94XX Class 0-6-0PT shunts empty passenger stock, while a Swindon Cross Country Class 120 multiple unit stands in the adjacent platform. The sturdy 94XX Class pannier tanks were designed by F. W. Hawksworth and introduced in 1947, while the Class 120 dmus were built in 1958 for employment on longer-distance cross-country routes – their passenger accommodation having a 'main line' ambiance similar to that provided on InterCity trains. The unit seen in the picture was probably working on the Central Wales route between Swansea, Llanelly and Shrewsbury. The Class 120 units had all been withdrawn by 1989, but one intermediate trailer survives in preservation on the Great Central Railway – this solitary vehicle being a trailer buffet second.

Right: Swansea High Street

A further view of the platforms at Swansea High Street during the 1960s, with a Class 52 locomotive on the extreme right and two sleeping cars in Platform 5. At the time of writing the Great Western main line is being electrified on the 25 kV ac overhead system between Paddington, Bristol and South Wales, the intention being that electric trains will be running to and from Swansea 'sometime between 2018 and 2024'. Swansea now generates around 2 million passenger journeys per annum and, as such, it is the fourth busiest station in Wales.

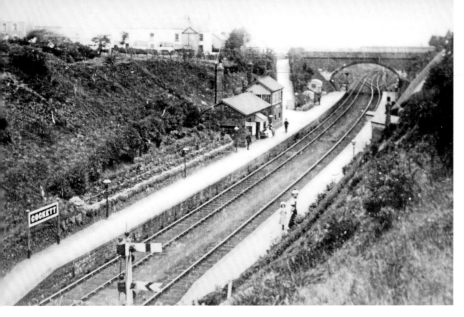

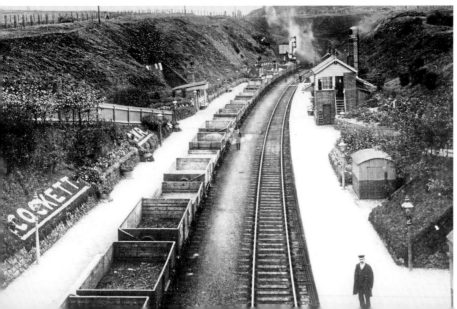

Cockett

From Swansea, the line heads westwards across the neck of the Gower Peninsula, and down trains are faced with rising gradients as steep as 1 in 52 on the three-mile climb to Cockett summit. In 1912 the GWR opened the 'Swansea District Line' as a bypass route for heavy coal trains, Fishguard Boat Trains and other through workings – the gradients on this new line being no steeper than 1 in 120. The Swansea District route has always been used mainly by freight trains although, at the time of writing, Arriva Trains Wales operate a Monday to Saturday service of two or three passenger services each way via this alternative route.

Cockett station (217 miles) was preceded by the 788-yard Cockett Tunnel. This small station was opened May in 1871 and closed with effect from 15 June 1954. The upper photograph is looking west towards Fishguard during the Edwardian period, while the lower view is looking eastwards in the opposite direction towards the tunnel mouth. The main station building was on the down platform, alongside a standard Great Western gable-roofed signal cabin. The 1938 Railway Clearing House *Handbook of Stations* shows that Cockett was able to deal with coal, livestock and general merchandise traffic. The yard crane had a lifting capacity of 6 tons, and private sidings served Messrs J. Thomas & Sons. In steam days, heavy trains required banking assistance on the climb to Cockett Summit and, for this reason, short sidings were provided to accommodate for banking locomotives.

Right: Llanelli

Running on more or less dead-level alignments, the route continues to Llanelli (225¼ miles), a more important station, opened on 11 October 1852, and known for many years as 'Llanelly'. Here, the South Wales main line connected with the Llanelly & Mynydd Mawr Railway and the Lanelly Railway & Dock Co. – the Mynydd Mawr line being a goods-only mineral line, whereas the Llanelly Railway (absorbed by the GWR in 1889) carried both passenger and goods traffic, and gave the GWR a lengthy branch to Llandilo, which was also used by the London & North Western Railway as part of the Central Wales route from Shrewsbury. In recent years Central Wales services have run via Llanelli (where a reversal is necessary), the original L&NWR route between Pontardulais and Swansea Victoria having been closed with effect from 15 June 1964. The accompanying photograph shows a Great Western express in the down platform at Llanelli, circa 1910.

Left: Loughor

Descending on gradients as steep as 1 in 50, trains run westwards via Gowerton (219½ miles) and Loughor (221½ miles). Opened on 1 August 1854, Gowerton remains in operation, but neighbouring Loughor, which was opened on 11 October 1852, was deleted from the railway system with effect from 4 April 1960. The main station building, on the up platform, was a modest, gable-roofed structure, similar in appearance to those found at other minor stations on the South Wales main line. The station was signalled from a standard Great Western signal cabin that was sited to the east of the platforms on the down side, while the station's goods-handling facilities included a private siding link to the nearby Broad Oak & Beli Glas Colliery and the Lougher Foundry. The photograph is a post-closure view, looking eastwards along the up platform.

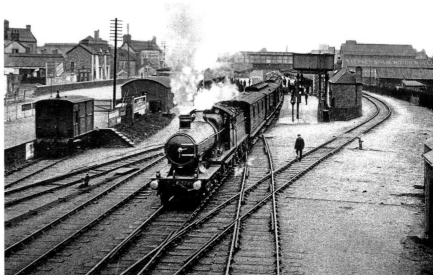

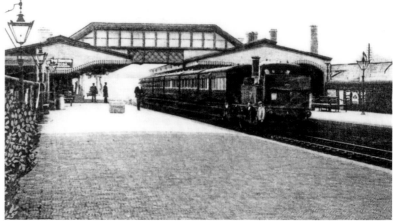

Llanelly

Above: A down passenger train is seen at Llanelly around 1910.

Left: An atmospheric view of Platform 2, the main up platform, around 1962, looking south-east towards Paddington. In the early 1900s, the station issued about 268,000 tickets per annum, rising to 368,391 tickets in 1913, and 385,897 bookings in 1923; in that same year, the station issued 2,154 season tickets, suggesting that many regular travellers may have preferred to pay their travelling expenses in this convenient way.

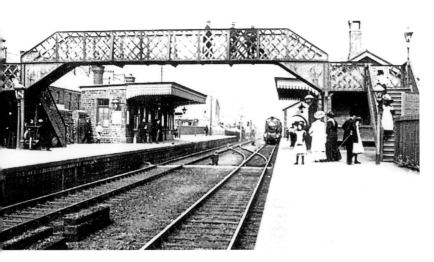

Left: **Pembrey & Burry Port**
Hurrying westwards along a dead-level section of track, trains reach Pembrey & Burry Port (229½ miles). This wayside station was opened on 11 October 1852 and, prior to rationalisation, its infrastructure had included a gable-roofed 'Brunelian' station building on the down side, together with a subsidiary waiting room on the up platform. The goods yard, to the east of the passenger platforms on the down side, contained the usual range of facilities, including coal wharves and a typical broad gauge style goods shed. There was also a link to the Burry Port & Gwendraeth Valley Railway, which had commenced operation as a goods-only line in 1869, and carried passengers from 1909 until 1963. The railway remained in use for several years thereafter as a mineral-carrying line, Class 03 and cut-down Class 08 diesel shunters being employed because of limited clearances between Burry Port and Coedbach.

Right: **Pembrey & Burry Port**
Class 158 unit No. 158782 calls at Pembrey & Burry Port station with the 11:05 a.m. Carmarthen to Manchester Piccadilly Arriva Trains Wales service on 15 July 2006. There are plenty of ways to cross the line here. The road overbridge in the background has its own dedicated footbridge alongside, while the station has retained its GWR lattice-girder footbridge. In addition, a public footbridge carries a footpath across the line at the east end of the station. The attractive Victorian station buildings shown in the previous view have now been replaced by simple, open-fronted waiting shelters and a very basic 'Portakabin' type hut, which serves as a ticket office.

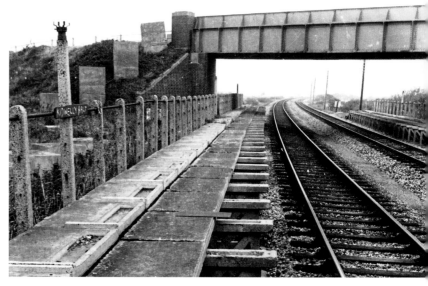

***Left*: Lando Halt**

Curving onto a northerly heading, the route continues to the site of Lando Halt, the gradients on this section of line being negligible. Lando Halt (sometimes referred to as 'Lando Platform') was opened in 1915 to serve a large ordnance factory that was being established on a coastal site near the railway. This non-timetabled halt was used by workmen's trains that ran to and from Swansea, while the infrastructure provided here included a private siding link that gave access to an extensive internal railway system – the siding connections being controlled from a 42-lever signal cabin sited on the down side. The halt was closed in June 1964.

***Right*: Kidwelly Flats Halt**

Heading north-north-eastwards, the route continues to the site of Kidwelly Flats Halt, which was opened on 6 August 1941 to serve the nearby Pembrey aerodrome, and closed with effect from 11 November 1957.

Kidwelly

Kidwelly (234½ miles), a much more important stopping place, was opened on 11 October 1852. The station was formerly equipped with 'Brunelian' buildings of the now-familiar type, the main 'chalet' type station building and goods shed being on the up side, while additional waiting room and toilet facilities were available for travellers on the down platform. The up and down platforms were linked by a plate-girder footbridge, and the signal cabin was sited to the south of the platforms on the down side. Regrettably, these Victorian buildings have been replaced by simple 'bus stop' style waiting shelters.

Successive editions of the Railway Clearing House *Handbook of Stations* reveal that there were a number of private sidings in and around Kidwelly, including rail links to the Dinas Silica Brick Works and Kidwelly Gas Works. In addition, there was a connection to the Kidwelly Quay branch of the Burry Port & Gwendraeth Valley Railway, which passed beneath the main line at the south-eastern end of the station. On 31 January 1984 a mile long connecting line was formally opened between Kidwelly and Coedbach, and this new connection enabled BR to close the former BP&GVR main line between Burry Port and Coedbach. Kidwelly thereby became the junction for the remaining section of the BP&GVR, which remained in use for anthracite traffic until final closure in 1996.

Confusingly, Kidwelly was also the junction for the Gwendraeth Valleys Railway, a single-track mineral line that diverged from the main line at the south end of the station, and ran northwards before terminating at Mynydd-y-Garreg, a distance of about two and a quarter miles. This very minor line had been opened around 1871, and in terms of route mileage it was the smallest railway, operating its own traffic, to have been taken over by the GWR at the time of the Grouping. The railway was officially closed with effect from 29 August 1960, although it appears that traffic had ceased in the previous year.

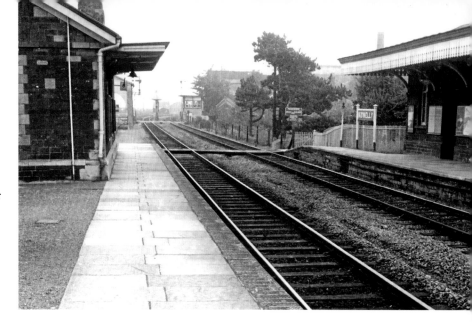

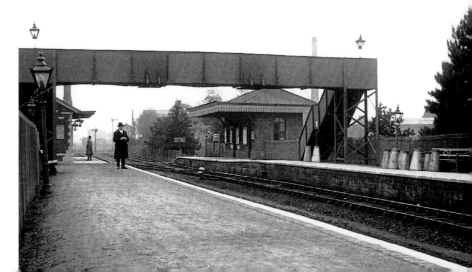

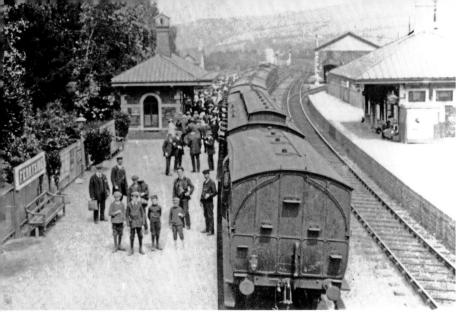

Ferryside

Having left Kidwelly, the South Wales route follows the Gwendraeth down to the sea, the still-extant station at Ferryside (238¾ miles) being virtually on the shore-line. Opened on 11 October 1852, this station once sported a complete range of 'Brunelian' buildings. The main station building on the up side was a classic 'chalet' design, with a low-pitched hipped roof and wide, overhanging eaves, while the down side building was of similar design, with Italianate architectural features. The station also boasted a typical broad-gauge style goods shed, similar to those found elsewhere on the South Wales route, while a minor road crossed the line on the level at the south end of the platforms. The station was signalled from a gable-roofed brick-and-timber cabin sited immediately to the south of the down platform.

The upper picture is looking northwards from the footbridge during the early years of the twentieth century, while the lower photograph was taken from a similar vantage point about sixty years later. The goods shed can be seen to the north of the platforms on the up side. Sadly, the historic 'Brunelian' buildings that can be seen in these photographs have now been replaced by ugly, 'bus stop' style waiting shelters. Ferryside issued 26,891 tickets in 1903, falling slightly to 25,576 bookings in 1913 and 23,207 by 1933 – the apparent decline being attributable, at least in part, to the increasing use of season tickets. In recent years the station has generated around 20,000 passenger journeys per annum.

Opposite: Ferryside

Class 50 locomotives Nos 50031 *Hood* and 50049 *Defiance* run alongside the Towy estuary at Ferryside with the 6.19 p.m. Pathfinder Tours Fishguard Harbour to Paddington West Wales Excursion on 10 August 2002.

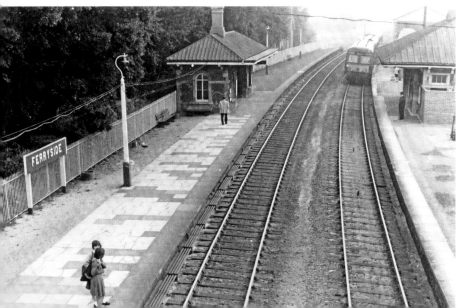

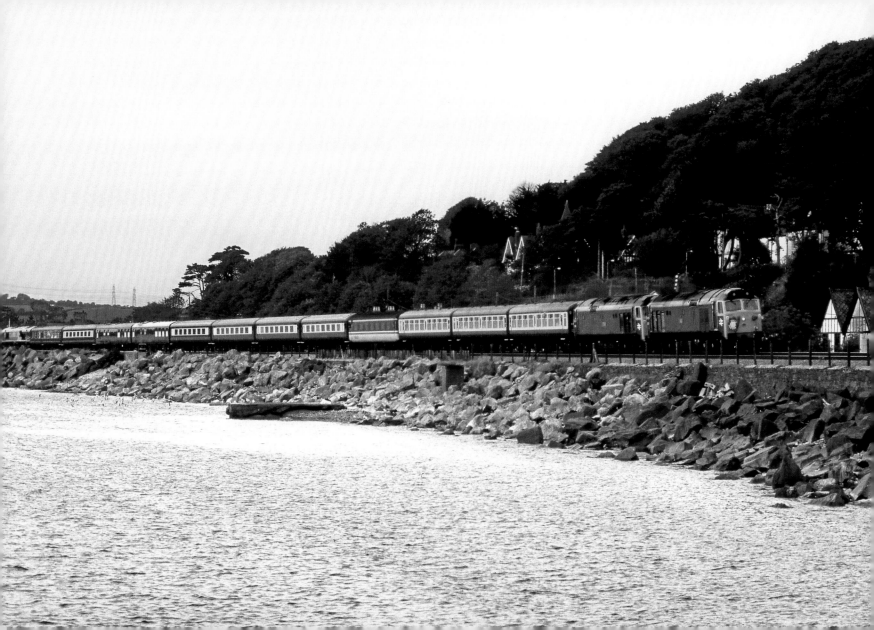

Ferryside

Left: Photographed from the top of a conveniently-placed Second World War concrete pill-box, Class 50 locomotive No. 50049 *Defiance* runs alongside the Towy estuary at St Ishmael, near Ferryside, with the 1.35 p.m. Fishguard Harbour to Cardiff Central Arriva Trains Wales service on 15 July 2006. Initially this working had started out as a Saturday-only train, but it later became a weekly service.

Below Left: Class 150 unit No. 150283 passes the extremely scenic setting of St Ishmaels with the 1.10 p.m. Milford Haven to Cardiff Central Arriva Trains Wales service on 15 July 2006.

Below Right: Class 37 locomotive No. 37402 *Bont Y Bermo* passes St Ishmael in glorious summer sunshine on 7 June 2003 with the 1.55 p.m. Fishguard to Rhymney service

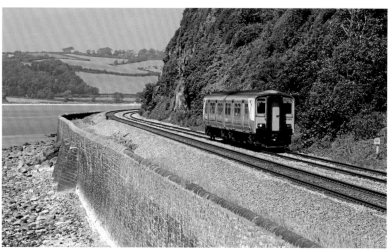

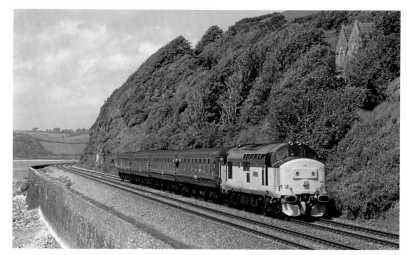

Carmarthen

Having followed the Towy Estuary for several miles, trains reach the important intermediate station of Carmarthen (245¾ miles). When opened on 1 October 1852, the South Wales line had ended in a temporary terminus on the south side of the town, but this became a through station when the SWR was extended to Haverfordwest in 1854. In March 1859, the Carmarthen & Cardigan Railway was opened from its junction on the north side of SWR station at Mrytle Hill, and a new station was built on the north side of the river – the earlier station being renamed 'Carmarthen Junction', while the new one became 'Carmarthen Town'. At the end of the Victorian period, it was decided that the former Carmarthen & Cardigan station would be rebuilt, and on 1 July 1902 an entirely new station was brought into use on a fresh site to the south of the original, the old and new facilities being separated by the intervening River Towy.

The resited station was aligned from north-east to south-west, with its main station buildings on the down side. The original layout provided up and down platforms on either side of a lengthy crossing loop – the running lines being separated by a third line, or 'Middle Road', while the platforms were equipped with terminal bays. The crossing loop was soon extended at its southern end to form a double track from Carmarthen Junction, while a large motive power depot was opened on the east side of the passenger station on 11 February 1907.

The main station building, shown in the photographs, was a single-storey, brick-built structure, with tall chimneys and a full-length platform canopy. Externally, it conformed to the usual style of Great Western architecture – buildings of generally similar design having been constructed in large numbers over a period of about forty years between the early 1870s and the outbreak of the First World War. A smaller building was provided on the opposite platform, while the up and down sides of the station were linked by a fully-roofed, plate girder footbridge.

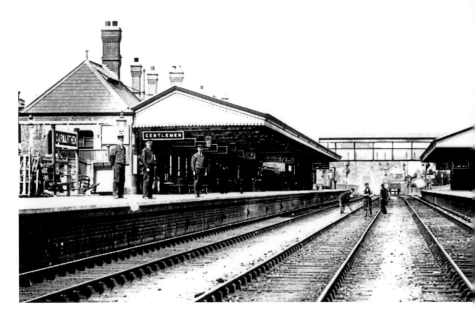

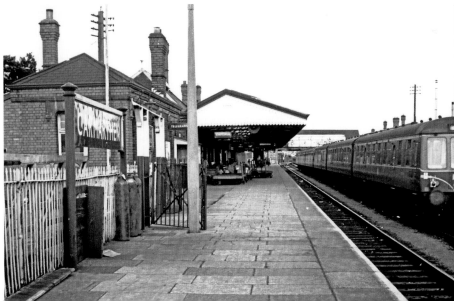

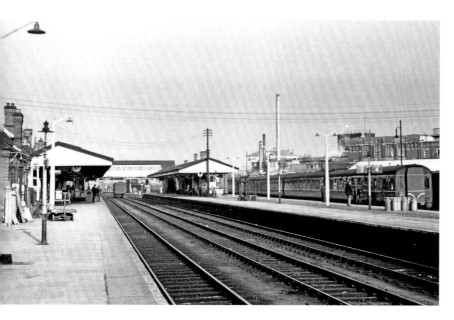

Left: **Carmarthen Town**

Various changes were carried out during the 1930s, when the GWR adapted the 'middle road' for use as a goods loop and constructed an 'up back platform line' behind the up platform. Other improvements included the provision of an array of carriage sidings, which were installed on the up side of the station near the engine shed. The middle road was particularly useful when passenger vehicles were attached to or detached from through services. The station was controlled from two signal cabins, Carmarthen Crossing Signal Box being sited to the north of the platforms, while Carmarthen Station Signal Box was situated a short distance to the south of the station. Both of these boxes had been opened in 1902, though in August 1931 the original crossing box was replaced by a new cabin on a contiguous site. Other signal cabins in the immediate vicinity included those at Carmarthen Goods Yard, Carmarthen Junction, Carmarthen Bridge and Llanstephan Crossing.

Right: **Carmarthen Junction**

Carmarthen's goods handling facilities were concentrated mainly on the site of the original Carmarthen & Cardigan station on the north side of the river, which became a goods yard in 1902. The 1938 Railway Clearing House *Handbook of Stations* shows that the station was fully-equipped with a range of facilities for coal, livestock, furniture, vehicles and general merchandise traffic; the yard crane was capable of lifting 6 tons. Further goods handling-facilities were available at Carmarthen Junction station, where the goods sidings were also used as a marshalling point for trains proceeding into Carmarthen Town or northwards onto the Aberystwyth line. In 1938, Carmarthen Junction was able to handle most types of goods traffic, including furniture and livestock, but no passenger facilities were available at that time – the station having lost its remaining passenger services in 1926. The photograph shows Carmarthen Junction station around 1920.

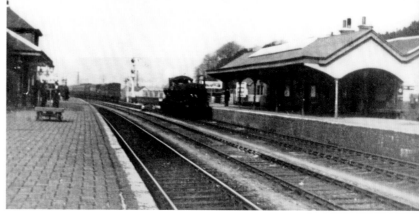

Left: Carmarthen Town – The Engine Shed

Carmarthen locomotive depot, coded 87G during the BR period, incorporated a large shed building containing six parallel shed roads and two additional repair roads. The running shed, on the east side, measured about 180 feet by 96 feet, while the repair shops, offices and stores measured around 176 feet by 56 feet. There was a 165 feet diameter turntable and a typical GWR style coaling stage, which was surmounted by a 76,000 gallon water tank. Engines ran to or from the depot via a trailing connection from the 'Up Back Platform Line', or by means of a similar connection from the up main line. In 1947, this relatively large shed had an allocation of forty-nine locomotives, including eight Hall Class 4-6-0s, two Grange Class 4-6-0s, six 28XX 2-8-0s, four 42XX Class 2-8-0Ts, eight 2251 Class 0-6-0s, four Dean Goods 0-6-0s, one Metro 2-4-0T, one 14XX Class 0-4-2T and the usual assortment of GWR pannier tanks.

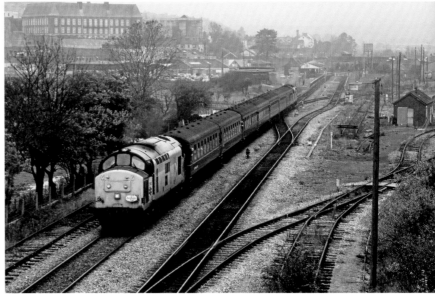

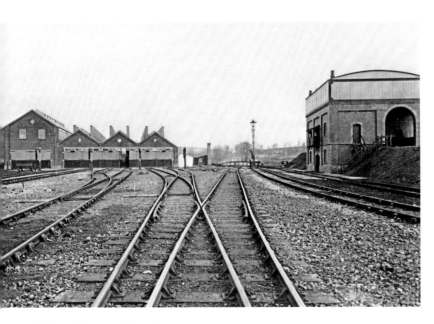

Right: Carmarthen Town

Class 37 locomotive No. 37902 accelerates away from Carmarthen station with the 7.45 a.m. Pathfinder Tours Birmingham New Street to Fishguard Harbour Dyfed Docker rail tour on 16 November 1996. Carmarthen station is now situated at the end of a short dead-end spur that branches off from the Cardiff to Fishguard route. It would have been possible for this train to have used the direct line, but as it was 'top-and-tailed' with sister locomotive No. 37412, it was no hardship to make the short detour into Carmarthen. The line formerly continued northwards beneath the road bridge that can just be seen in the background, with cross country routes radiating out to such places as Newcastle Emlyn, Lampeter and a connection with the Central Wales line at Llandeilo. Sections of these lines are being developed as 'heritage' railway – the Gwili Railway having been established between Bronwydd Arms and Danycoed, while the Teifi Valley Railway operates a narrow gauge railway on part of the Newcastle Emlyn branch.

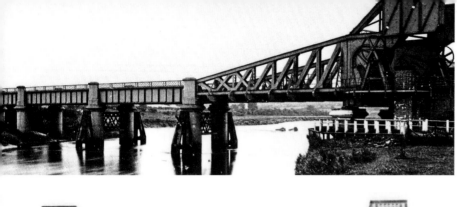

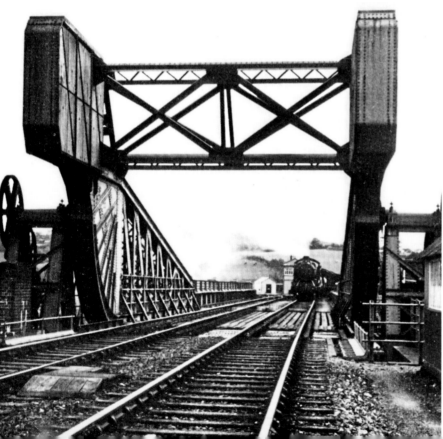

Carmarthen Rolling Lift Bridge

Carmarthen Bridge, to the west of Carmarthen, was one of the many major bridge works on the South Wales main line. The original Brunel-designed structure had featured a wrought iron 'drawbridge', which could be lifted by means of hydraulic machinery and then rolled back onto the rails, leaving a 50-foot opening to permit the passage of shipping. This interesting structure lasted until 1911, when it was replaced by an electrically-operated rolling lift bridge. Rolling lift bridges were, at that time, still something of a novelty. In the words of *The Great Western Railway Magazine*, 'the first rolling lift bridge was built over the Chicago River, in Chicago, by the late William Scherzer, in 1895'.

The bridge carries a double track, its width being 28 feet 6 inches. The fixed spans had openings of 60 feet, while the lifting span was 80 feet on the skew with a clear span of 90 feet; its rolling weight was 220 tons, and the bridge was brought into use on 11 July 1911 – the first passenger train to cross it being an Ocean Liner special from Fishguard to Paddington. It is interesting to note that the Carmarthen Bridge was one of three rolling lift bridges built under GWR auspices in 1911, the other two being in Ireland on the GWR-sponsored Cork City Railway.

The example at Carmarthen was built by the Cleveland Bridge & Engineering Company and it had five fixed spans and one lifting span. The fixed spans were formed of steel plate girders resting on cylindrical piers, while the lifting section was constructed of steel lattice girders. Bridges of this type were counter-balanced by two huge balance boxes, which were filled with iron and attached behind the quadrants – a comparatively small amount of power being required to pull the span into its open position or push it back into place.

Left: Sarnau

Having reversed in Carmarthen station, down trains take the west arm of the Carmarthen triangle, and proceed more or less due westwards to the site of a closed station at Sarnau (249¾ miles). This wayside stopping place was opened by the GWR on 6 June 1888 and closed with effect from 15 June 1964. The infrastructure here included up and down platforms for passenger traffic and a small goods yard, the latter facility being sited to the east of the platforms on the up side. The passenger station and the goods yard were separated by an intervening level crossing, which was controlled from a 14-lever signal box on the down side. The main station building, on the up platform, was another standard Great Western hip-roofed structure – this example being of timber construction with external timber framing and vertical match boarding.

Right: Sarnau

A general view of the station, looking east towards Paddington, with the wooden station building to the left and the gable roofed signal box visible beyond the level crossing. The signal cabin outlived the station by several years, having survived until the level crossing gates were replaced by lifting barriers in 1979. In 1913, Sarnau had issued 7,026 tickets, but this fairly respectable total had dropped to 851 by 1934 and only 597 by 1938. Goods traffic showed a similar decline over the same period, 4,234 tons of freight being handled in 1913, falling to 2,477 tons in 1930 and 1,758 tons by 1938. These disappointing traffic statistics suggest that Sarnau would have been barely profitable by the later 1930s. With paybill expenses running at £593 per annum by 1938, and total receipts of £1,319 in that same year, the station must have covered its basic costs – although rates and operating expenses would have eaten into what little profits there were.

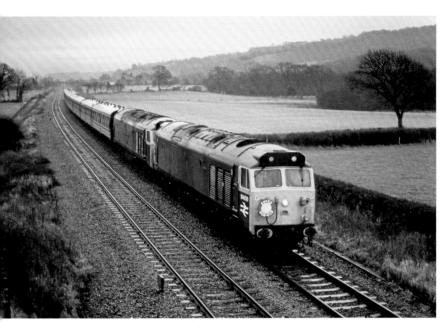

Right: **Sarnau**
Gleaming in its new coat of red paint, EWS Class 37 locomotive
No. 37422 *Cardiff Canton* passes Nantyrhebog, near Sarnau, with the
9.11 a.m. Rhymney to Fishguard Harbour Wales & Borders service on
21 June 2003. The train has just crossed a large area of boggy ground that
now forms the Cors Goch Llanllwch National Nature Reserve.

Left: **Sarnau**
Class 50 locomotives Nos D400 and 50007 *Sir Edward Elgar* pass the site
of Sarnau station at the head of the bizarrely named 6.25 a.m. Pathfinder
Tours Crewe to Robeston Dyfed Dub-Dub rail tour on 8 January 1994.
No. D400 was later renumbered 50050 and, as such, it was named *Fearless*,
while No. 50007 had originally been numbered D407. Both locomotives are
now owned by Boden Rail Engineering Ltd.

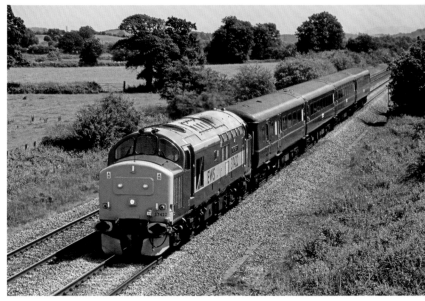

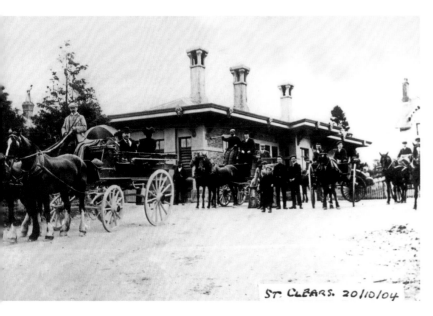

ST. CLEARS. 20/10/04

Left: St Clears

Maintaining their westerly heading, down trains are faced with a rising gradient of 1 in 181, followed by a 1 in 102 descent towards St Clears (253¼ miles), the site of another closed stopping place. Opened with the line on 2 January 1854, St Clears boasted a 'Brunelian' station building and an equally-characteristic broad-gauge type goods shed, the main station building being on the down platform, whereas the goods shed was on the up side of the running lines. The up and down sides of the station were linked by a lattice girder footbridge, while a minor road crossed the line on the level at the west end of the platforms. The hip-roofed station building differed in relation to those found on the original section of the South Wales main line, although its stylish, Italianate features were clearly in the Brunelian tradition. The photograph, taken on 20 October 1904, shows a number of horse-drawn vehicles in the station yard.

Right: St Clears

A view of St Clears station during the British Railways period, around 1960, looking west towards Fishguard, with the main station building to the left and the South Wales Railway goods shed to the right of the picture. St Clears issued about 26,000 tickets per annum during the Edwardian period, falling to 9,178 in 1931, and an average of 5,500 ordinary tickets per year during the later 1930s – by which time, however, there were around eighty season ticket holders. In 1903, the station typically handled about 14,758 tons of freight traffic, rising to 18,346 tons in 1913 and 20,272 tons by 1931. This very rural station employed a dozen people at the start of the twentieth century, while by 1920 the number of employees had increased to fourteen. St Clears was closed with effect from 15 June 1964.

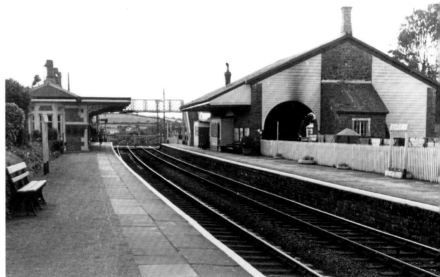

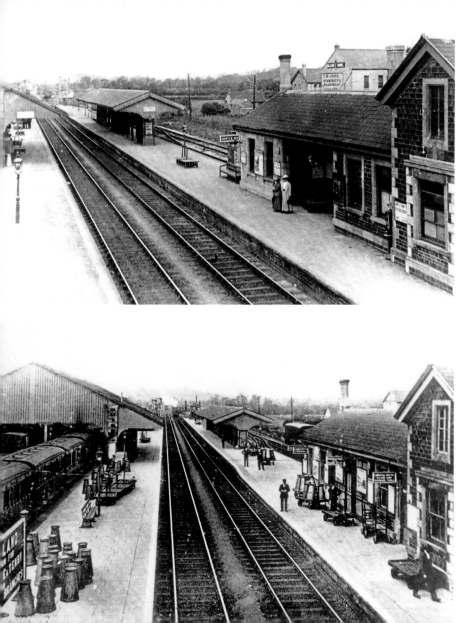

Whitland

Having surmounted a miniature summit beyond St Clears, westbound trains pass through a short tunnel before reaching Whitland (258¾ miles), the junction for branch services to Cardigan and Pembroke Dock. This station was opened on 2 January 1854, and it became a junction on 4 September 1866, when the Pembroke & Tenby Railway extension from Tenby to Whitland was ceremonially opened. The Cardigan branch was brought into use in the following decade – the first section from Whitland to Crymmych Arms being opened on 12 July 1875, while the line was completed throughout to Cardigan on 1 September 1886. The Cardigan branch was closed to passengers with effect from 10 September 1962, and to all traffic in 1963, but Whitland remains the junction for services to Pembroke Dock.

The station is aligned from east to west, with the main goods yard sidings to the south of the running lines. In steam days, there were four platforms for passenger traffic, Platforms 2 and 3, the main up and down platforms, being in the centre of the station while Platform 1 was a terminal bay on the up side, and Platform 4 was an additional through platform on the down side of the station. Cardigan trains usually departed from Platform 4, whereas arriving branch trains used either platform 1 or platform 2. The two main platforms were both over 500 feet in length, with watering facilities for up and down trains.

The main station buildings were on the up side, and the road from Lampeter to Whitland crosses the running lines on the level at the east end of the platforms. A lattice girder footbridge connected the up and down sides of the station, and both platforms were partially covered by canopies. The photographs, both dating from the early 1900s, are looking west towards Fishguard, with the up platform to the right of the picture.

Opposite: Whitland
A detailed view of the up platform during the early years of the twentieth century.

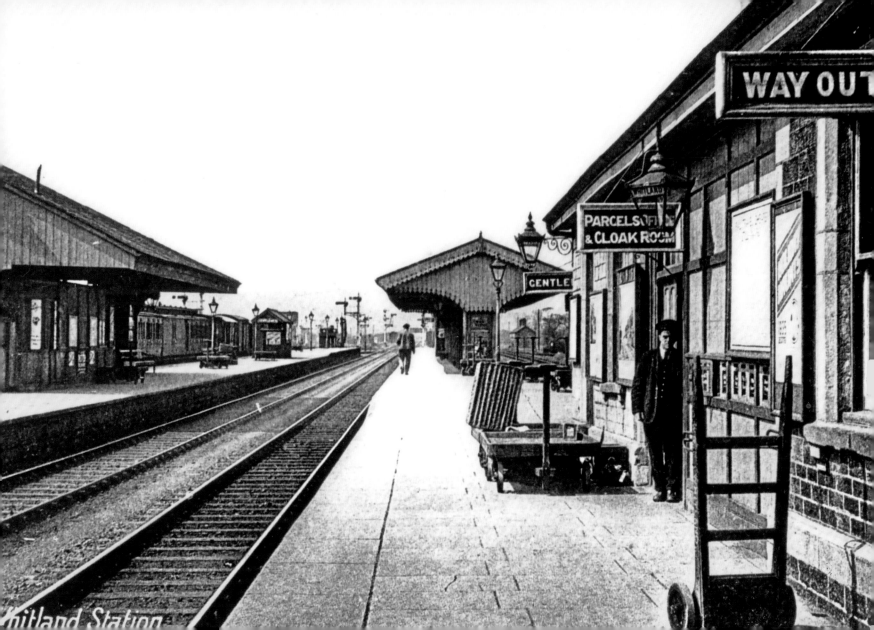

WAY OUT

PARCELS OFFICE & CLOAK ROOM

GENTLE

Whitland Station

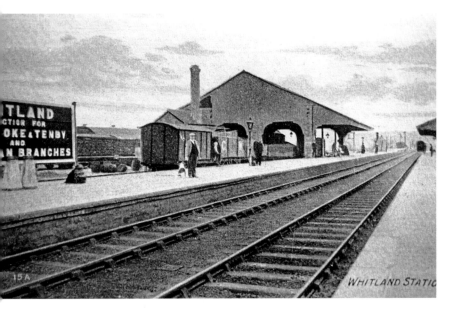

Left: Whitland

The facilities provided at Whitland prior to rationalisation included a large goods shed on the down side, together with the usual range of goods facilities, including cattle pens, loading docks and a fixed yard crane. As shown in the photograph, the goods shed incorporated a platform canopy, similar to the one provided at St Clears. Additional sidings were available on the up side of the running lines, and there was also a rail-connected milk depot. The extensive track layout was controlled from two signal boxes at each end of the station known as Whitland East and Whitland West boxes. The station was extensively rebuilt in the 1950s, when the Victorian buildings were replaced by ugly modern structures. The up side building is still in situ at the time of writing, albeit in a locked and semi-derelict condition – Whitland having been demoted to the status of an unstaffed halt. Two platforms remain in use, the trackwork in the up bay having been lifted, while the down bay survives in an out-of-use condition.

Right: Whitland – The Engine Shed

When opened throughout to Whitland in 1866, the Pembroke & Tenby Railway had terminated in a separate station, which was sited to the south of the main line platforms on the down side. The former Pembroke & Tenby engine shed later became part of Whitland motive power depot which, in the early BR period, incorporated a single-road shed building measuring about 100 feet by 25 feet. In 1921, Whitland had an allocation of twelve engines, while in 1947 the local allocation comprised eight 45XX Class 2-6-2Ts, one 41XX Class 2-6-2T, one 81XX Class 2-6-2T, one 2251 Class 0-6-0, two 74XX 0-6-0PTs, and six 1901 Class 0-6-0PTs – a total of nineteen locomotives. The arc-roofed building shown in the photograph was later rebuilt with a gable roof, but the facilities at this Welsh depot remained extremely primitive.

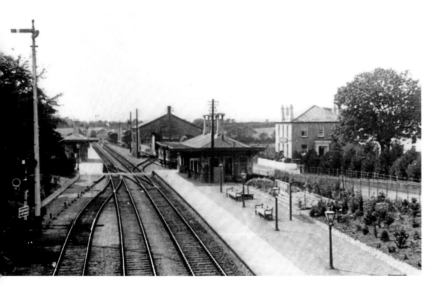

Left: Clynderwen

Clynderwen (264½ miles), a little over 5 miles beyond Whitland, was opened on 2 January 1854, its original name being 'Narbeth Road'. The name 'Clynderwen' was adopted in 1875, while in 1980 the spelling was altered to 'Clunderwen'. In steam days the track layout here incorporated staggered up and down platforms and a small goods yard, the yard sidings being on the up side, while a minor road is carried across the line on a single-span bridge at the east end of the station. The goods yard, closed in 1965, originally contained an archetypal Brunelian goods shed, together with coal wharves and a cattle loading dock, but the Victorian shed that can be seen in the photographs was later replaced by a more modern structure. The accompanying photograph is looking west towards Fishguard around 1912.

Right: Clynderwen

A similar view, looking westwards from the road overbridge around 1912. the main station building can be seen to the right, while the Brunel goods shed and the down side station building can be discerned in the distance. The station building was a hip-roofed structure that contained the usual booking office, waiting room and public toilet facilities. It featured three tall chimney stacks and a platform canopy, while the front of the building was slightly-recessed to form a sort of loggia beneath the projecting canopy.

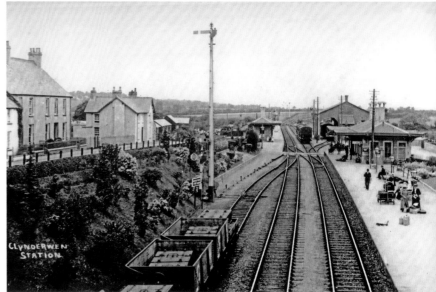

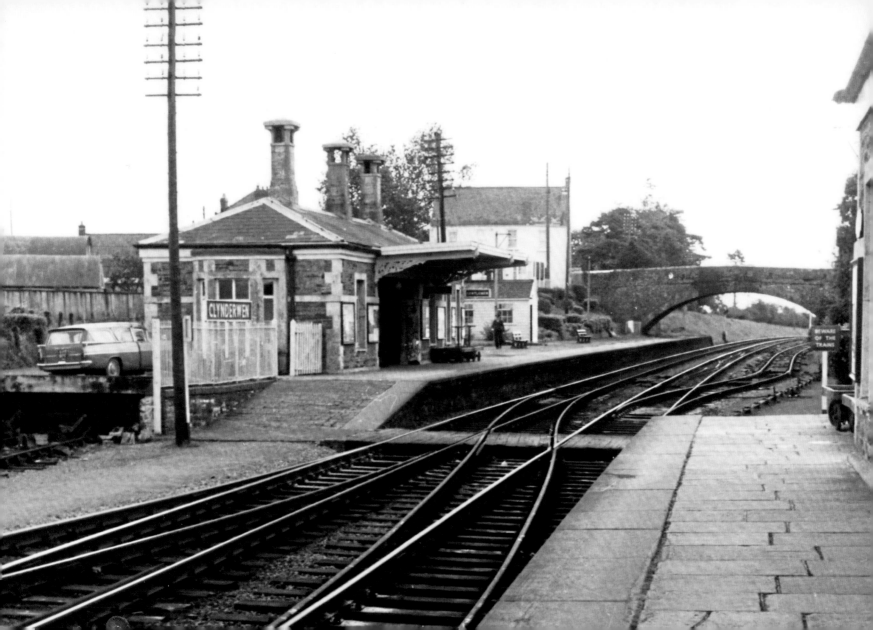

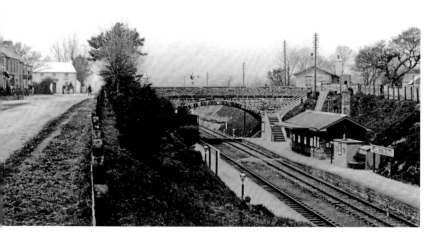

Left: Clarbeston Road – The Original Station

Continuing west-north-westwards on a series of rising gradients, the steepest of which is at 1 in 130, trains reach Clarbeston Road (270¾ miles). Opened by the South Wales Railway on 2 January 1854, this station was transformed into a junction by the opening of the Clarbeston Road & Letterston line on 30 August 1906. In its original guise, the station was a simple two-platform stopping place with its station building on the up side and a very basic goods yard to the west of the platforms. A minor road was carried across the line on a shallow-arched bridge at the west end of the station, and this provided a convenient means of access to the platforms, which were approached by means of wooden steps. Unfortunately, the station building was destroyed by fire on 9 July 1907. The fire started in a lamp room, and spread rapidly to the adjoining station building – attempts to extinguish the raging inferno with water-filled buckets having been totally ineffective.

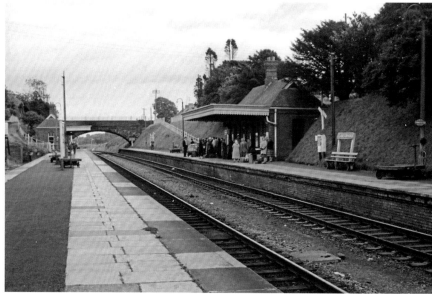

Right: Clarbeston Road – The Rebuilt Station

As a result of a major remodelling operation that was completed in July 1914, Clarbeston Road was transformed into a three-platform station with up and down platforms for through traffic and a terminal bay for Fishguard services on the up side. The new station was sited a few yards to the west of the original on the Fishguard side of the road overbridge, and access to the re-sited platforms was via gently-sloping ramps. Brick-built station buildings were available on both platforms, while sidings were laid out on both sides of the running lines. The enlarged goods yard, on the down side, was able to deal with, livestock, horse boxes and general merchandise traffic, while the station was signalled from a standard GWR signal cabin sited on the up side of the running lines.

Opposite: Clynderwen

A view of the main station building prior to its demolition.

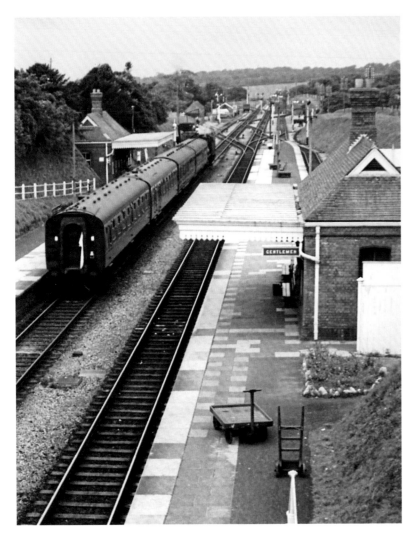

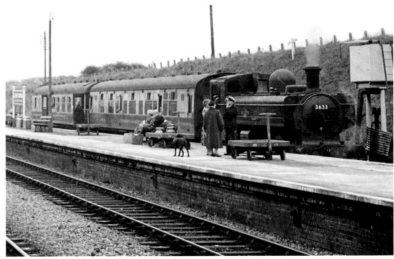

Clarbeston Road

Above: Collett 57XX Class 0-6-0PT No. 3633 waits in the Fishguard branch bay with a two-coach local train around 1962.

Left: A general view of the station looking west towards Fishguard from the road bridge around 1962, the main station building being visible to the right. The junction with the Neyland branch is situated beyond the sidings that can be seen in the distance. Water columns were available at the east end of the up platform and the west end of the down platform, while locomotives could also take water from a small tank sited at the east end of the bay platform.

Clarbeston Road

Right: Class 37 locomotive No. 37179 departs from Clarbeston Road with an evening train around 1978. The formation consists of four BR Mk 1 coaches in blue-and-grey livery, including a BG full brake immediately behind the locomotive.

Below Left: A general view of the station during the late 1970s, showing the very basic modern buildings that replaced the earlier brick station buildings. The station is now equipped with fully-glazed 'bus stop' type waiting shelters.

Below Right: Class 37 locomotive No. 37179 accelerates away from Clarbeston Road.

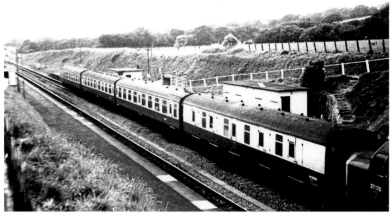

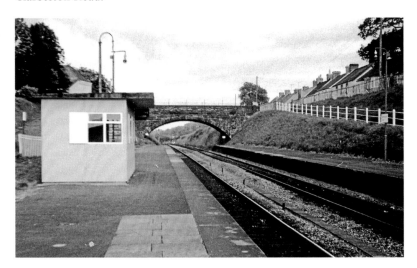

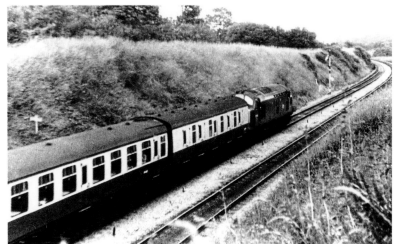

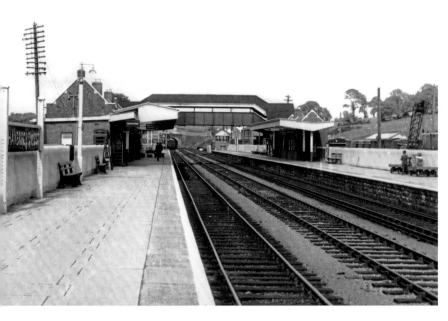

Right: The Milford Haven Branch – Johnston

Prior to rationalisation Johnston (281 miles), the next stop, had featured up and down platforms, the main station building, of obvious South Wales Railway appearance, being on the down side, while a fairly substantial waiting room was sited on the opposite platform. The up and down platforms were linked by a lattice girder footbridge, and the station was signalled from a gable-roofed cabin that was sited to the south of the platforms on the far side of a road overbridge. The goods yard was located to the north of the platforms on the down side, while the Milford Haven branch diverged from the Neyland line a short distance to the south of the station. In earlier years, a goods-only branch had diverged eastwards to serve the Freystrop Colliery. Although barely a mile in length, the Freystrop colliery line was worked as a private railway with its own locomotives. The colliery was re-opened (as the 'Hook Colliery') during the 1930s.

Left: The Milford Haven Branch – Haverfordwest

As mentioned earlier, the South Wales main line originally terminated at Neyland, the railway having been opened between Carmarthen and Haverfordwest on 2 January 1854, and completed throughout to Neyland on 15 April 1856. An intermediate station was provided at Johnston, and on 7 September 1863 this became the junction for the present Milford Haven line. These lines were relegated to branch line status following the completion of the Fishguard scheme in 1906, but they nevertheless remained of considerable importance in terms of both passenger and goods traffic. Haverfordwest (276¾ miles) is the principal intermediate station on the Milford Haven route. In steam days it had long up and down platforms together with a third 'middle line' and a relatively modern, brick-built station building dating from around 1938. The third line has now been lifted, but the station is still staffed, and its amenities include a ticket office, waiting room, toilets and a refreshment room.

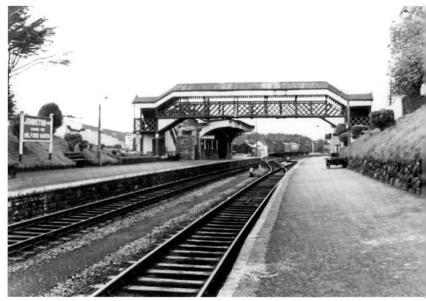

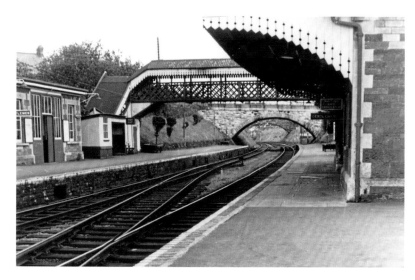

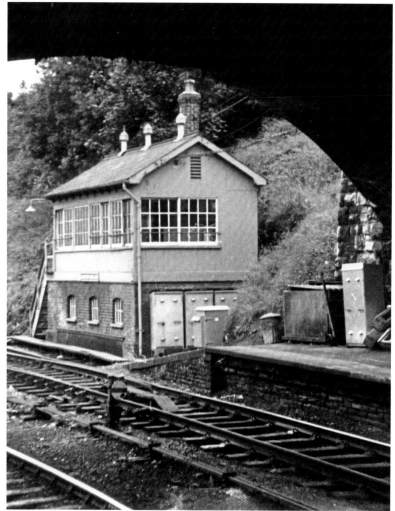

The Milford Haven Branch – Johnston

Above: A view of Johnston station during the early 1960s, looking south towards Milford Haven, with the main station building to the right of the picture. Johnston became an unstaffed halt in 1964, and only one platform now remains.

Right: Dating from the 1880s, Johnston Signal Box was of relatively early construction. It was at one time equipped with a 33-lever frame, but this was later replaced by a 44-lever frame – the box being extended at the Paddington end to make room for the enlarged frame. An additional 10-lever cabin, known as Johnston West Box, was opened in 1917, this new cabin being sited at the junction between the Milford and Neyland lines. The west box was closed in 1935, but the main signal box at Johnston station remained in use until October 1988.

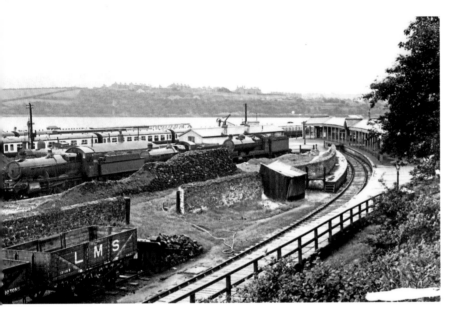

Left: The Neyland Branch

Falling continuously on gradients as steep as 1 in 75, the line formerly continued to Neyland (285½ miles), once the western terminus of the South Wales Railway. When opened in 1856 this station had been known as 'Milford Haven', but its name was changed to 'New Milford' in 1859 and then to 'Neyland' in 1906. The harbour facilities here were retained after the opening of the Fishguard line – Neyland being an important fish and goods terminal. The track layout here was curious, insofar as the station had one short, straight platform and one sharply-curved platform, the two platforms being separated from each other by an array of parallel goods sidings. The Neyland branch was closed with effect from 15 June 1964, but freight trains continued to run to and from a construction depot that had been set up in the old station in connection with the building of the Gulf Oil Refinery at Waterston.

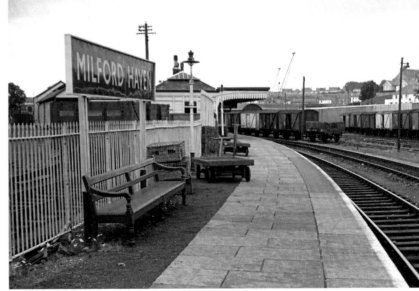

Right: Milford Haven

Opened on 7 September 1863, Milford Haven (284¾ miles) was originally regarded as a branch but, following the demise of the neighbouring Neyland route, Milford Haven has become the terminus of a 27½ mile line from Whitland. The terminus is approached by four miles of falling gradients, while passenger facilities consist of a single curved platform, which formerly boasted a timber-framed station building with a hipped roof and a projecting platform canopy. However, this standard Great Western structure has been demolished, and the station is now equipped with a simple waiting shelter and a small Portakabin that serves as a ticket office. Prior to rationalisation, the passenger station had been surrounded by goods lines and sidings, as shown in this circa-1962 photograph, but much of the former railway land around this down-graded terminus is now occupied by car parks and a supermarket.

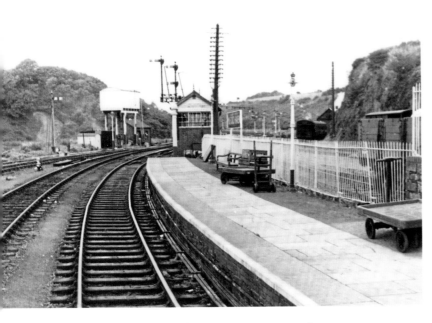

Left: Milford Haven

A further view of Milford Haven station, looking north towards Whitland during the 1960s. The standard Great Western gable-roofed signal cabin that can be seen just beyond the platform contained a 52-lever frame. The box was abolished in 1978. In the early 1900s Milford Haven station issued about 43,000 tickets each year, while in recent years the station has generated around 62,000 passenger journeys per annum.

Right: Milford Haven – The Waterston Branch

Milford Haven developed as a major oil port after the Second World War, the volume of traffic being so great that new branch lines were constructed to serve Herbranston (Esso), Waterston (Gulf) and Robeston (Amoco) refineries in 1960, 1968 and 1974 respectively. These freight-only branches were occasionally traversed by enthusiasts' specials, as shown in this photograph of Class 50 locomotives Nos D400 and 50007 *Sir Edward Elgar* heading along the Waterston branch in pouring rain on 8 January 1994. The train also visited Fishguard Harbour and the nearby Robeston Oil Refinery. The Amoco refinery at Robeston is still open, but the Waterston and Herbranston lines have now been closed.

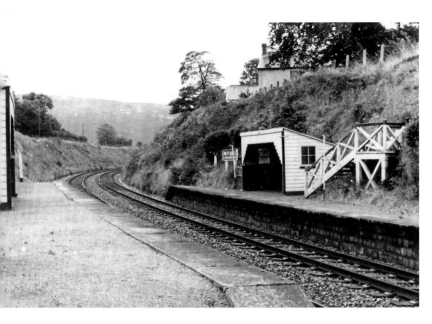

Right: Wolf's Castle Halt
A further view of the halt during the BR period, looking north-west towards Fishguard. The suffix that can be seen on the station nameboards says 'For Treffgarne Rocks' – a nearby local beauty spot. Wolf's Castle was, at one time, the site of a signal cabin, which had presumably been installed as an intermediate signal box to break up what would otherwise have been a lengthy block section between Clarbeston Road and Letterston Junction. The signal box was abolished in the early 1920s, while the halt was itself closed with effect from Monday, 6 March 1964.

Opposite: Wolf's Castle Halt
Class 37 locomotives Nos 37686 and 37274 approach Treffgarne Gorge with the 3.08 p.m. Pathfinder Tours Fishguard Harbour to Coventry Pembrokeshire Pageant rail tour on 2 August 1997. The tiny church of St Margaret can be seen in the background.

Left: Wolf's Castle Halt
Having looked at the lines to Neyland and Milford Haven, we must now resume our journey along the main line to Fishguard. On leaving Clarbeston Road station, Fishguard services immediately reach Clarbeston Road Junction, where the Fishguard route diverges from the original South Wales main line. Heading first westwards, and then northwards, the double-track route runs through a verdant landscape, dotted here and there with white-washed cottages and farmsteads. Having passed through the 243-yard Spittal Tunnel, down trains soon reach the site of Wolf's Castle Halt (276¾ miles). Opened on 1 October 1913, this very basic stopping place was equipped with short platforms and simple open-fronted waiting shelters. The halt was situated in a cutting, public access being by means of wooden stairways from a skew girder bridge at the north end of the platforms. The photograph is looking south-east towards Paddington during the early 1960s.

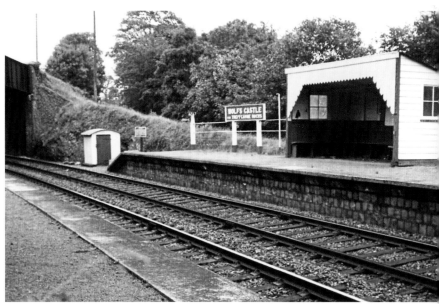

Right: Welsh Hook Halt

A further view of the extremely primitive facilities at Welsh Hook Halt. As the main line passenger services to and from Fishguard Harbour ran in connection with the cross-channel ferry route to Rosslare, they were of limited use to ordinary travellers, but local traffic was nevertheless catered for, albeit to a limited extent, by stopping services on the main line which called at Welsh Hook and the other intermediate stopping places. In 1947, for example, there were eight up and eight down trains, with an extra down working on Mondays, Wednesdays and Fridays. This pattern of operation came to an end in April 1964, when the intermediate stations between Clarbeston Road and Fishguard Harbour were closed.

Left: Welsh Hook Halt

Turning onto a north-westerly heading, the line continues along dead-level alignments for a distance of around 3 miles. On 5 May 1914, a stopping place was opened at Welsh Hook (278½ miles). Facilities here were very basic, in that there were no raised platforms, although waiting shelters were provided for the benefit of local travellers – one of these being a simple wooden shelter, while the other was a standard Great Western arc-roofed corrugated iron shed. Like Wolf's Castle, Welsh Hook Halt became a victim of rationalisation in the 1960s, and it was closed with effect from 6 March 1964.

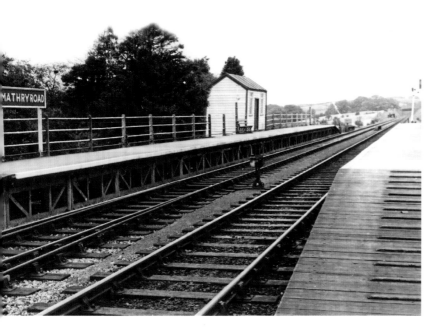

Left: Mathry Road

In contrast to Wolf's Rock and Welsh Hook, Mathry Road (280½ miles), the next stopping place was a proper station with a booking office and goods facilities. It was opened on 1 August 1923 and was equipped with very short staggered platforms, together with a single siding for goods traffic on the up side. The main station building was a simple wooden hut incorporating a booking office, waiting room and toilet facilities, while the adjacent goods yard was able to deal with coal, general merchandise and livestock traffic. There was, at first, no signal box, the siding connection being worked from a ground frame. In later years, the station was rebuilt with parallel platforms, while a 14-lever signal box was opened on 23 November 1925, the cabin in question being an all-timber structure that had originally been installed at Wolf's Castle.

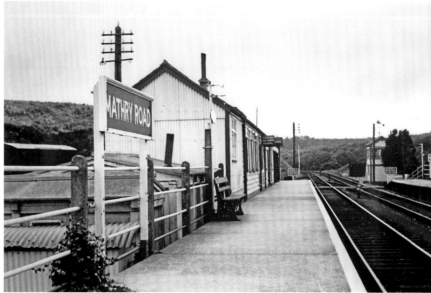

Right: Mathry Road

A detailed study of the main station building, looking towards Paddington, around 1962. The signal box was 'switched out' for most of the time, but it came into its own when the daily pick-up goods train called at the station. It is interesting to note that, as late as 1923, the Great Western was giving serious consideration to the idea of constructing a 10 mile branch from Mathry Road to St David's, at an estimated cost of £350,000. In the event, nothing came of this proposal, although in August of that year the company introduced a 'road motor' service between Mathry Road and St David's. The service consisted of three return trips on weekdays, with a through trip to Fishguard on Thursdays only. The St David's bus route was subsequently handed over to the Western Welsh Omnibus Company. Like many of the other intermediate stations on the Fishguard route, Mathry Road was closed with effect from 6 April 1964.

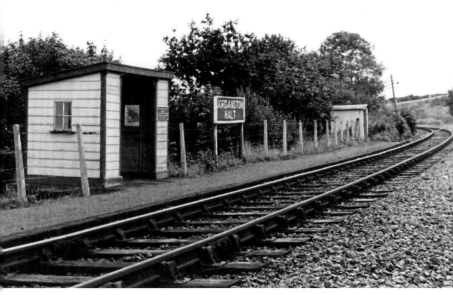

Letterston Junction & Jordanston Halt

From Mathry Road, the railway runs north-eastwards to the site of Letterston Junction, where the North Pembrokeshire line from Clynderwen formerly converged with the main line. Although the 19 mile North Pembrokeshire route lost its passenger services in 1937, the branch lingered on as a goods only route with a meagre service of one train a day. A rail-served munitions depot was, however, subsequently established at Trecwn, and this ensured that Letterston Junction remained a place of some importance until comparatively recent years.

The layout at Letterston Junction was quite sophisticated, in that goods loops were provided on both sides, in addition to the actual junction. The layout was controlled from another standard GWR signal cabin that was sited on the up side in the 'V' of the junction between the main line and the Trecwn branch. In operational terms, Letterston Junction also marked the point at which the double track from Clarbeston Road became single for the remainder of the journey to Fishguard. There were no platforms for passenger traffic at Letterston Junction, although Jordanston Halt, the next stopping place (282¾ miles) was only a short distance further on. This very simple request stop was opened at the same time as Wolf's Castle Halt, on 1 October 1923. Its modest facilities comprised an open-fronted waiting shelter and a nameboard, but there was no platform, passengers having to board or disembark from their trains with the aid of portable wooden steps. The halt was closed in April 1964.

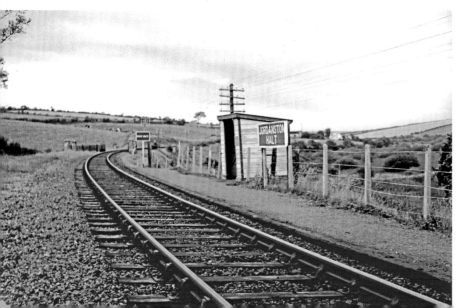

Fishguard & Goodwick

Now heading in a northerly direction, trains approach Fishguard on a 1 in 50 falling gradient, which in steam days sometimes presented problems for up workings, banking being a regular feature of operations on this part of the route. Interestingly, the Great Western had commenced work on a deviation line prior to the First World War in an attempt to eliminate the formidable Jordanston Bank, but this improvement scheme was never completed.

Fishguard & Goodwick station (285¾ miles), the penultimate stopping place, was a small station with up and down platforms for passenger traffic and a goods yard. The station was opened on 1 August 1899 as part of the North Pembrokeshire route and, as such, it predated the opening of the Clarbeston Road & Letterston Junction Railway by seven years. The goods yard was on the up side, while carriage sidings and a two-road engine shed flanked the running lines on the down side.

The station building, on the up platform, was a timber-framed structure with a low-pitched gable roof and a very small canopy, while the only building on the down side was a standard GWR hip-roofed signal cabin. The upper view shows 14XX Class 0-4-2T No. 1431 at Fishguard & Goodwick around 1956, while the lower view shows the wooden station building.

Fishguard & Goodwick was the setting for an unusual accident that took place on 11 July 1951, when the 6.40 p.m. auto service bound for Clarbeston Road, headed by a Collett 14XX Class 0-4-2T, left the station without the single-line staff and collided head-on with a down freight train headed by No. 6823 *Oakley Grange*; four railwaymen were injured as a result of the accident. It transpired that the driver of the local train had been distracted by the noise of detonators placed on the line because his train was conveying a wedding party, and in commenting on this incident, the inspecting officer observed dryly that 'detonators are expressly supplied to stop or warn trains in emergencies, not to speed them on their way'!

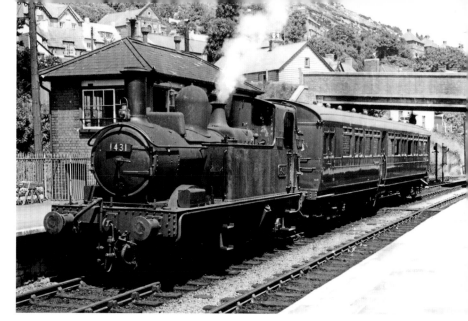

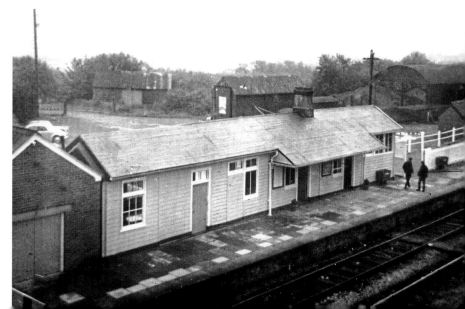

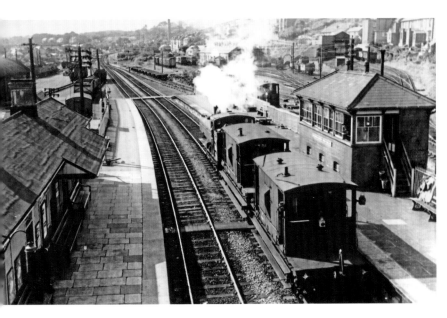

Right: **Fishguard & Goodwick**

Collett 14XX Class 0-4-2Ts Nos 1452 and 1431 stand in the platforms at Fishguard & Goodwick with push-pull workings during the 1950s. As far as can be ascertained, there had never been any need for a shelter on the down platform, which was used mainly by workmen travelling to and from the neighbouring harbour station. Although Fishguard & Goodwick station succumbed to rationalisation on 5 April 1964, revival followed shortly afterwards in October 1965, when the station was reopened in connection with the introduction of Motorail services between Paddington and Fishguard. Unadvertised workmen's services also continued to use the station in connection with the naval armaments depot at Trecwn. In the longer term, however, Motorail services ceased and Trecwyn has been closed, although the semi-derelict Fishguard & Goodwick station survived into the 21st century, and it was officially reopened on 14 May 2012, the necessary funding having been contributed by Network Rail and Pembrokeshire County Council.

Left: **Fishguard & Goodwick**

A view of the station looking southwards from the footbridge. The goods yard, to the left of the platforms, contained three dead-end sidings, one serving a cattle dock, while another terminated beside a corrugated iron goods shed. A 6-ton yard crane was able to deal with consignments of timber or other heavy items. The engine shed, on the opposite side of the running lines, normally housed around fifteen locomotives. The shed building was a standard GWR two-road structure, and the usual coaling and watering facilities were available, together with a locomotive turntable. In 1947, the local allocation included three Hall Class 4-6-0s, one Grange 4-6-0, a solitary 43XX Class 2-6-0, four 14XX Class 0-4-2Ts and six 57XX Class pannier tanks. The shed, sometimes known as 'Goodwick', was coded '87J' in British Railways days. It was closed in 1963.

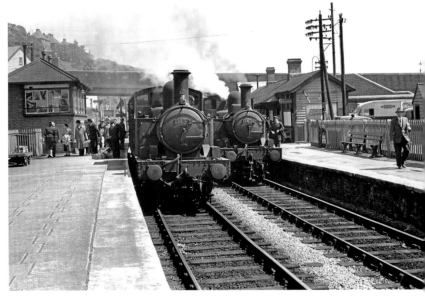

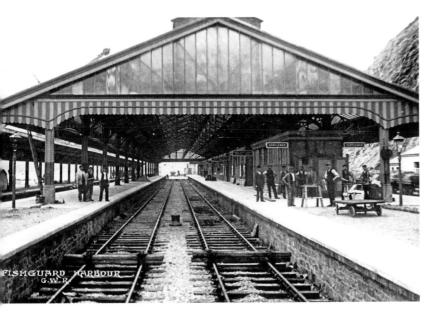

Left: Fishguard Harbour

From Fishguard & Goodwick, the line passes beneath a road overbridge and continues along the edge of Fishguard Bay for a short distance before terminating in Fishguard Harbour station, some 286½ miles from Paddington via Gloucester, and 261¼ miles from Paddington via the Severn Tunnel route. The layout here had originally incorporated two double-sided island platforms, providing four platform faces in all. The platforms were numbered in logical sequence from 1 to 4, Platform 1 being furthest from the water while Platform 4 adjoined the quay. Platforms 2 and 3, in the centre of the station, were spanned by an impressive overall roof with glazed end gables, while the station buildings were located on Platforms 1 and 2. Curiously, Platform 4 was arranged as a 'through bay', with platform faces on both sides, so that passengers could alight directly onto the quayside. The accompanying photograph shows the impressive train shed around the time of opening in 1906.

Right: Fishguard Harbour

A similar view, taken from a slightly different angle around 1906. The quayside was well-equipped with electric cranes, the largest of which was able to lift loads of up to 21 tons. In this context in is interesting to note that the official GWR publication *Instructions Relating to Irish Traffic* contains an intriguing reference relating to 'Heavy and Bulky Articles via Fishguard & Rosslare'; it seems that 'Ordinary Furniture Vans on their own wheels, Furniture Lift Vans, Railway Goods Wagons on their own wheels and single articles up to 25 feet in length and 8 feet 6 inches in width' could be conveyed to Rosslare and also (with slightly differing dimensions) to Waterford and Cork. This implies that railway vehicles could be loaded aboard the steamers and bodily transported to Ireland – the 21-ton crane being 'available for all classes of furniture vans, railway carriages and wagons, boilers and other heavy articles'.

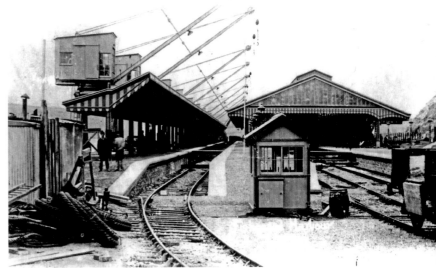

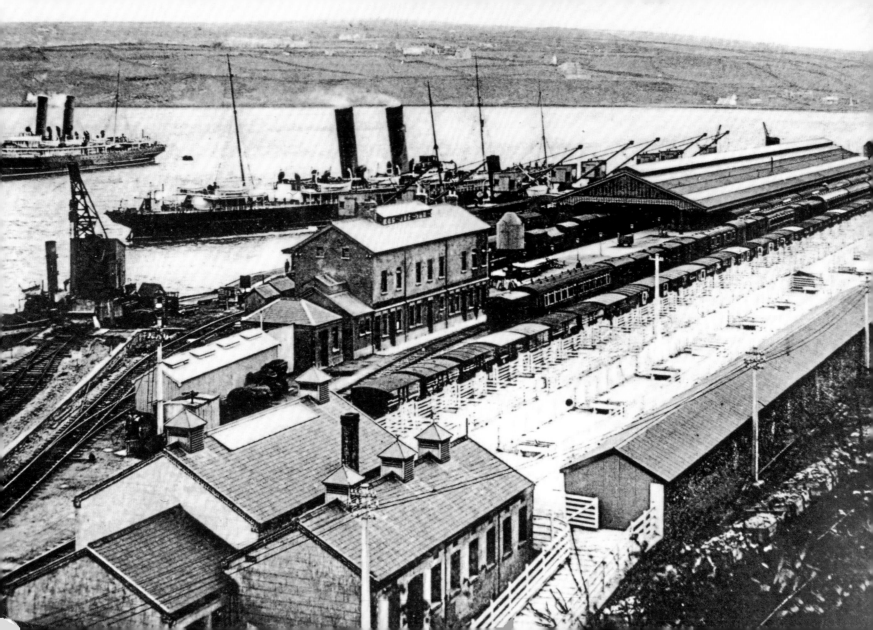

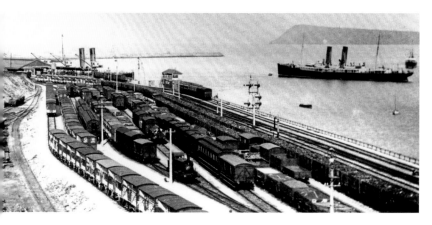

Left: **Fishguard Harbour**
A panoramic view of the goods sidings on the southern approaches to the passenger station. Cattle wagons are much in evidence, while this Edwardian photograph also shows two of the Great Western passenger steamers – their raised forecastles and huge raked funnels being obvious identification features. The train shed can be glimpsed in the distance. The descriptions of traffic in Instructions Relating to Irish Traffic are of particular interest. Traffic from Southern Ireland to England included passengers, ale and porter, potatoes, whisky, manure in bags, eggs, fish, fruit, moss, oats, hay and a variety of other agricultural products. In the reverse direction, traffic from England to Ireland included passengers, bicycles, biscuits, boots, iron, machinery, motor cars, leather, paper, tea, timber, tin plates, hats, hosiery and hardware. Another instruction in Irish Traffic urges English station agents to 'look out for horse dealers travelling to Ireland' and 'not only canvass for their traffic but also notify the Company's Irish Agent by wire, so that he may look out for them'.

Right: **Fishguard Harbour**
A further view of the train shed, looking northwards along Platform 3 during the early years of the twentieth century. The platforms were linked by an underline subway. Although Fishguard Harbour was designed primarily as an important Irish port, the Great Western directors hoped that ocean liners would call on their way between Liverpool and New York, enabling passengers and mail to be conveyed to Paddington in opposition to the established route via Queenstown, Dublin, Holyhead and Euston. On 30 August 1909 the Cunard liner RMS *Mauretania* did indeed call at Fishguard, and three special trains conveyed mails to Paddington. However, the decision to transfer most transatlantic liner traffic from Liverpool to Southampton was a major blow to the GWR, which meant that Fishguard never developed as a transatlantic port.

Opposite: **Fishguard Harbour**
This circa-1906 view underlines the importance of coal and cattle traffic on the Fishguard & Rosslare route. The cattle pens were capable of holding 'many hundred head of cattle', which could be herded from the steamers by means of a special gallery situated beneath the passenger station. The 21-ton electric crane can be seen to the left of the picture, while two passenger vessels are visible in the harbour.

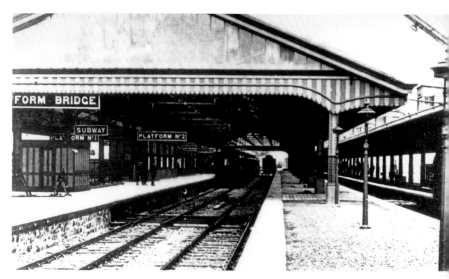

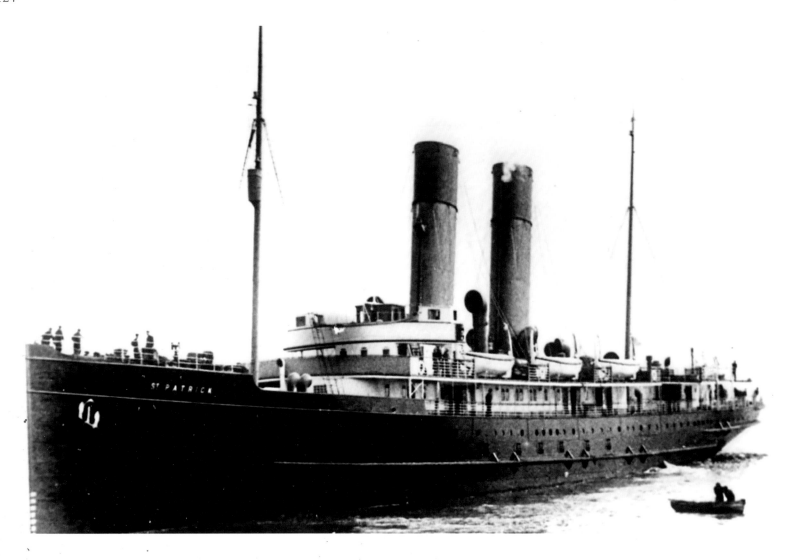

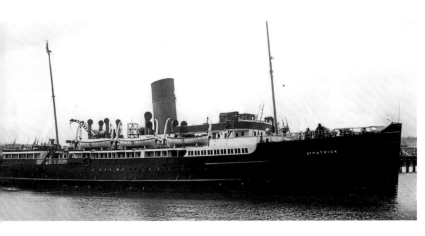

: Fishguard Harbour – The *St Patrick II*

The first *St Patrick* was disposed of in 1930. The second *St Patrick* was, in effect, a modernised version of her predecessor, the raised forecastle being a typical Great Western feature. Launched in 1930, this vessel was 281 feet overall with a top speed of 19 knots. Sadly, the *St Patrick II* was torpedoed in the Irish Sea in June 1941. In common with the other Irish steamers, the *St Patrick II* occasionally worked from Weymouth.

Right: Fishguard Harbour

Class 50 locomotives Nos 50007 *Sir Edward Elgar* and D400 stand alongside Platform 1 at Fishguard Harbour station with the Pathfinder Tours Dyfed Dub Dub rail tour on 8 January 1994. Having already visited various West Wales freight installations, including the now closed Waterston Branch, the tour participants were given an hour to sample the delights of rain-swept Fishguard, before the train departed as the 4.09 p.m. Fishguard Harbour to Crewe service.

Opposite: Fishguard Harbour – The *St Patrick I*

Built by John Brown & Co in 1906, the *St Patrick* was one of three turbine steamers constructed for service on the Fishguard & Rosslare route in 1906. This vessel had a somewhat unlucky career, having been involved in an alarming collision with the *St David* when entering Fishguard Harbour at 2.35 a.m. on the morning of 19 August 1927. Passengers were thrown out of their bunks by the force of the collision, and both ships sustained significant damage – although the prompt closing of the watertight doors avoided the danger of sinking, and both vessels were able to reach the quayside under their own steam. A female passenger recalled that 'everything was in an uproar. Most of the men were already on deck, but women and girls came tumbling up, some of them in their night clothes. She thought for a moment that they were all going to be drowned, but very soon the ship's officers restored order'. Just two years after this accident, the *St Patrick* was damaged by a major fire.

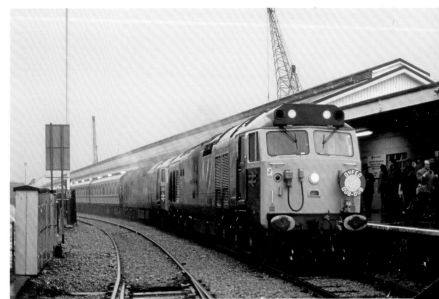

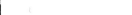

FISHGUARD. GWR

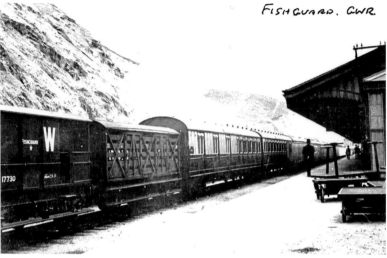

Fishguard Harbour

Left: Platform 1 during the Edwardian period. Great Western 'Toad' brake van No. 17730, visible to the left, was 'branded' to Fishguard. The slatted vehicle coupled next to it was a GWR 'Siphon', used for conveying milk in churns.

Below Left: A view of the station during the early 1960s; the brick building at the south end of Platforms 1 and 2 is obviously a later addition, as it does not appear in the earlier photographs.

Below Right: A further view of Platform 1, looking north towards the train shed.

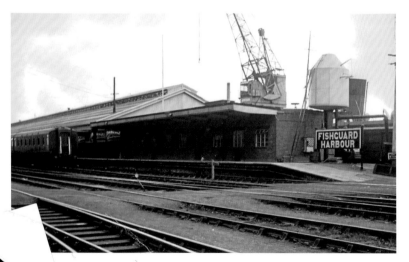

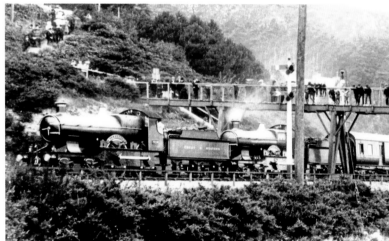

SHGUARD. GWR.

FISHGUARD HARBOUR

Left: Fishguard Harbour

Another view northwards along Platform 1 during the British Railways period, around 1964. The rapid growth of road transport after the Second World War and the development of 'Roll-on/roll-off' ('Ro-Ro') car ferries transformed the cross-channel business, and BR was obliged to reconstruct many of its ports in order cater for increasing road traffic. Thus, in 1972, the layout at Fishguard Harbour was modified, with a new car park and lorry terminal. In recent years, the remaining island platform has been served by just one line, which has its own run-round loop. A headshunt extends northwards onto the breakwater, while the modernised terminal building contains waiting rooms and a buffet.

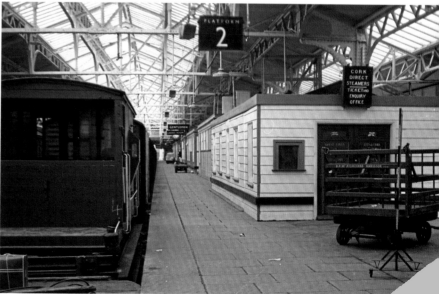

Right: Fishguard Harbour

A glimpse of Platform 2 during the 1960s. Fishguard Harbour station was owned by the Fishguard & Rosslare Railways & Harbours Company, which was jointly-owned by British Railways and Coras Iompair Eireann (CIE) after the railways were nationalised. In all, the company owned 105 miles of railway, comprising one mile at Fishguard and 104 miles in Ireland. The British Railways share passed into the hands of Sea Containers in 1984, and when the latter company sold most of its Sealink assets to Stena in April 1990 the company became a joint Swedish-Irish undertaking. At the time of writing Fishguard Harbour station is owned and managed by Stena, and railway tickets are no longer sold – passengers arriving without tickets have to buy them on the trains.

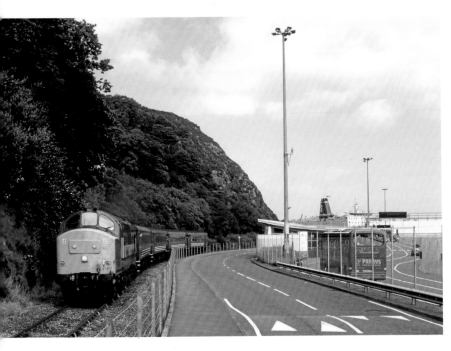

Right: Fishguard Harbour

A random assortment of Great Western and British Railways tickets from stations at the western end of the South Wales route, comprising eight Edmondson cards and one paper platform ticket. Great Western tickets were a darker shade of green than their British Railways counterparts. The BR privilege single from Fishguard to Rosslare (No. 2102) was a steamer ticket, which would not have involved a rail journey.

Left: Fishguard Harbour

Class 37 locomotive No. 37417 leaves Fishguard Harbour station with the 1.55 p.m. Wales & Borders service for Rhymney on 2 August 2003. The Irish ferry terminal can be seen in the background. Both the harbour station and the nearby Fishguard & Goodwick station are actually in the village of Goodwick, the town of Fishguard being over a mile away.

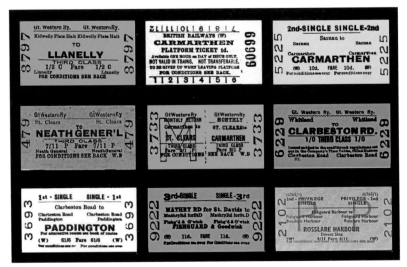